A BEGINNER'S GUIDE TO THE HUMANITIES

PHILIP E. BISHOP

Vallencia Community College

Prentice
Hall

UPPER SADDLE RIVER, NEW JERSEY 07458

Library of Congress Cataloging-in-Publication Data

BISHOP, PHILIP E.

A beginner's guide to the humanities / PHILIP E. BISHOP.
 p. cm.
 ISBN 0-13-019374-7
 Includes index.
 1. Arts. 2. Art appreciation. I. Title.

NX643 .B58 2003
700'.1—dc21 2002021832

VP, Editorial Director: *Charlyce Jones Owen*
Acquisitions Editor: *Bud Therien*
Editorial/Production Supervision: *Joanne Riker*
Prepress and Manufacturing Buyer: *Sherry Lewis*
Director of Marketing: *Beth Gillett Mejia*
Cover Art Director: *Jayne Conte*
Cover Designer: *Kiwi Design*
Marketing Manager: *Chris Ruel*

This book was set in 10/12 Stone Serif by East End Publishing Services, Inc. and was printed and bound by Courier Companies, Inc. The cover was printed by Phoenix Color Corp.

 © 2003 by Pearson Education, Inc.
Upper Saddle River, New Jersey 07458

Printed in the United States of America

10 9 8 7 6 5

ISBN 0-13-019374-7

Pearson Education LTD., *London*
Pearson Education Australia PTY, Limited, *Sydney*
Pearson Education Singapore, Pte. Ltd
Pearson Education North Asia Ltd, *Hong Kong*
Pearson Education Canada, Ltd., *Toronto*
Pearson Educación de Mexico, S.A. de C.V.
Pearson Education—Japan, *Tokyo*
Pearson Education Malaysia, Pte. Ltd
Pearson Education, *Upper Saddle River, New Jersey*

CONTENTS

1 PAINTING 1

2 SCULPTURE 15

3 ARCHITECTURE 27

4 MUSIC 44

5 THEATER 60

6 OPERA AND MUSICAL THEATER 76

7 DANCE 91

8 THE PRINTED IMAGE: PRINTS, PHOTOS, DIGITAL ART 105

9 MOVIES 121

PREFACE

I remember beginning to play basketball at age eight, a game I still play twice a week, rickety knees and all. My dad handed me a basketball and told me to throw it as high as I could against the garage wall. He wanted to see if I could reach the ten-foot rim. I must have done okay, because he went right out to dig the post-holes in the backyard for a basketball goal. I played my best games on that goal in the winter moonlight, dribbling on a frozen mud court.

Think of this handbook as the garage wall and postholes for a different game—a lifelong enjoyment of the arts. It's easy for folks to think they don't measure up to high culture. They're intimidated by the orchestra in white tie and tails, or the hallowed silence of a museum. They're puzzled by the painting they see on the walls or by the drama where nothing seemed to happen. And opera—isn't that fat ladies singing?

If it's confidence you lack, this handbook offers a gentle push through the door of that museum, theater, or concert hall. Once your fanny's in a seat at the Met or you're wandering the Louvre, this guide will deepen your experience of the moment. It teaches you to observe and enjoy, to think and feel in response to the arts. And afterwards at the bar or coffee-shop, or reading the museum guide or a newspaper review a day later, you'll find you speak the critical language of the arts. You'll know you're in the game when you find yourself in conversation with friends and family, and someone asks how you know all that.

Maybe I'm the person to give you courage because I started where many of you do—as a beginner. I was reared in a small-town family that hardly ever ventured to the big city for culture. The first real play I remember was my sister's high school musical. I wandered through some museums in college, but as a literature major, I didn't pay much attention. I could tell you the plots of dozens of novels, but just one painting

sticks in my memory—Goya's *Saturn Devouring His Children*. As a college student loose in Madrid, I wandered through a door at the Prado, turned, and Saturn stopped me cold.

Now I teach and write professionally about the visual arts (I'm art critic for a medium-sized city newspaper) as someone who's mostly self-taught. What I know about the visual and performing arts comes from reading books, magazines, and newspapers, and listening to smart people, and then constantly seeking out new experiences in the world of high culture. I have learned to understand and love the arts through a lifelong, incremental layering of knowledge and experience.

As a teacher by vocation, I think that's the best way to learn. Being smart about art (and about other things, too) doesn't require a sophisticate's birthright or a minimum intelligence score or even a college degree. Art smarts come to an open mind that's willing to reach out, take a risk, and encounter new experience. I'm hoping that mind is yours.

WHAT'S IN THIS BOOK

Nine of the chapters that follow are each devoted to an art as you'll encounter it out there in the real world of museums, galleries, concert halls, theaters—all the places and spaces of culture where it actually exists. In each chapter, you'll find some or all of these elements.

REAL ENCOUNTER

Recollections and reflections are from my own encounters with works of art in this medium. Some are drawn from my own journal entries, written in the shelf-full of spiral notebooks. Some are based on my collection of performance programs, newspaper articles and reviews, and postcards—all the stuff I keep as a physical memory of the encounter. I often do the same thing with great meals at friends' homes or restaurants as a way of recalling the pleasure of the moment. It's a mental snapshot of the encounter.

TOOL KIT

A glossary of essential terms provides definitions of everything you need to know about this art.

STYLE GUIDE

A short list of important styles or principal artists.

THE EXPERIENCE

Step-by-step directions guide you through the experience of an art. The kind of things that anybody who's played the game for a while knows to do. Beginners need instructions.

A COMPANION TO THE ART

Pages you can photocopy and take with you that provide questions to ask, terms to remember, and a reminder to forget about that dumb handbook. Think and feel for yourself!

ACKNOWLEDGEMENTS

I wish to thank Richard Rietveld, Suzanne Salapa, Mary Jo Pecht, and Ralph Clemente for their support. Thanks also to my editor Bud Therien for prompting me to begin this project and to Joanne Riker for bringing it so efficiently to completion

Prentice Hall's reviewers offered valuable suggestions: Rick Davis, Ricks College; Stan Kajs, Chesapeake College; Wayne Swindall, California Baptist University; Blue Greenberg, Meredith College; Charles Carroll, Lake City Community College; and Cortlandt Bellevance, Atlantic Cape Community College.

Philip E. Bishop

1
PAINTING

IN THE BEGINNING, there was the picture, and it was magic. It was a wild magic that painted bulls and horses stampeding across the walls of prehistoric caves. Exhausted from their journey into the earth, hallucinating from the effect of flickering light and chanted incantation, stone-age worshippers must have felt their souls rise to meet these awesome painted creatures. And in their ecstasy, the celebrants took up pots of paint and added their own painted beast to the wall.

It is a much tamer magic that makes pictures flicker across our computer or video screens, transmitting images from a distant world and transporting us out of our own. Whether it's rock art in southern Africa or graffiti tags in New York City, humans have felt compelled to picture their world. Pictures have always been more than a visual record. They're are an alternate way of seeing, an enhanced vision. We are the picture-making animal and in pictures we make magic.

HOW TO TALK IN PICTURES

A picture on a wall, a wooden board, a page of parchment or paper, even pixels on an electronic screen—any image in two dimensions that has height and width but not depth—makes a picture. The icons that image-making software puts across the bottom of the screen constitute the same pictorial vocabulary as stone-age art. In Paleolithic times, they probably spit the paint onto the wall. Today we more likely use a brush.

Picture-making is not only about depiction, it's also about truth. A painted scene of the life of Jesus or the Buddha isn't just a composite of lines, shapes, and colors. Neither is a graffito silhouette by young Keith Haring, the 1980s artist who slapped his pictures up while the subway

cops weren't watching. These pictures are assertions of human will and belief, alternate worlds and alter egos that we encounter in the painted image.

THE WORLD OF PAINTING

In modern societies, we're surrounded by images, pasted, posted, or projected. The image that most readers think of as a "painting" is a painted canvas hanging on a wall, probably in a museum or a wealthy household. These are one-of-a-kind images, not like the mechanically or electronically reproduced images that bombard the viewer on the streets of Tokyo or New York. We'll say more about mechanically produced images—prints, photographs, movies—in later chapters. For now, we're considering the variety of images made by a hand applying pigment to a flat surface—the Chinese fabric scroll that rolls out twenty meters long, as well as the still-resplendent painted walls of ruined palaces on the island of Crete.

The world's pictorial traditions are as varied as the human impulse to depict our world and ourselves. To honor, to remember, to imagine, to revere, to control, to document—the motives for making pictures are as complex as the human mind itself. Pictures mimic the human act of seeing and intensify the pleasure we find in viewing. But the peculiar pleasures of different pictorial arts vary widely. Think of the posters that adorn a teenager's bedroom walls—pop music stars, sports heroes—as compared to the wall paintings of a Hindu temple. The motive is to honor an exalted being, whether it's Krishna or Michael Jordan, and to sanctify a space with the being's visual presence. The image brings to the space something of a sacred or superhuman power, regardless of the rats that may scurry below or the dirty socks that lie the corner.

The meaning of pictures is found not just in their subject, but in their medium and style as well. You've probably thumbed through a stack of snapshots of a vacation trip, reminiscing about the fun you had. Compare this experience, though, to slowly unrolling a silk scroll painted with a mystical Asian landscape or a riotous parade. With each turn of the spindle, the scroll reveals a different scene. The eye can pause on this detail or that, and the viewer can meditate on the slow progress of the world. The photo snapshot and the silk scroll carry with them entirely different philosophies of human experience. They imply different ideas of what matters in life and how we should attend to it.

What do paintings do? They bring reality before our eyes by falsifying it. By falsifying it, they show us some fact or truth that otherwise would remain unseen. Wherever you find yourself in the world, look at what's painted and you will learn.

A REAL ENCOUNTER

DIEGO'S DOG

The painting called *Las Meninas (The Maids of Honor)* by Diego Velázquez is one of the most famous in the world. It shows the painter in the palace of his patron, King Philip IV of Spain, painting (apparently, at first glance) the king's daughter and her retainers. I knew this painting for years and had actually seen it as a college student. But when I saw it again on a visit to Madrid, I was astonished by one thing: that enormous and remarkable dog. I thought, this must be one of the greatest dogs ever painted, dozing there in the sun like a royal sphinx, painted in Velázquez's rough and lively detail. But what can this dog mean?

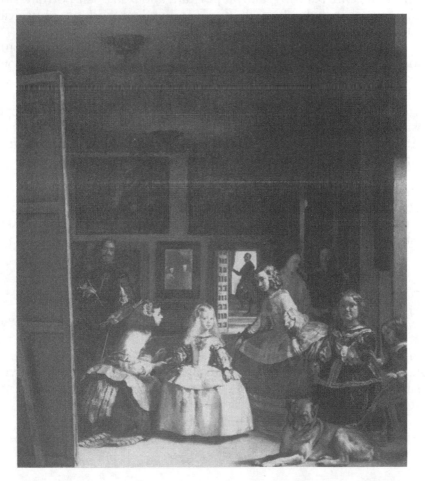

Figure 1.1 Diego Velázquez, *Las Meninas (The Maids of Honor)*, 1656. Oil on canvas 10'5" x 9'1" (3.18 x 2.76 m). Museo del Prado, Madrid. ©Scala/Art Resource, NY.

The dog might be a *symbol*, conventionally a symbol of fidelity. But there's nothing else in the picture to match this clue. The dog's presence indicates that the picture's subject is a *genre scene*, a scene of daily life in the painter's studio. But the subject may instead be a royal portrait since the center of attention is the resplendent princess. Velázquez would paint this girl dozens of times, advertising her beauty and wealth to potential husbands in Europe's other royal families. But why would he paint an ordinary dog with the same loose brushwork and sense of vitality as he painted a princess?

It was a question I didn't answer until I had thought and read about this painting for several years more. I think the dog advertises Velázquez's skill and stature as an artist. The painter's own presence in the scene, conspicuously near the princess, complicates the picture's subject yet again. It's a genre painting, a royal portrait, and also a self-portrait, since Velázquez has included himself, brush in hand, at work on a huge canvas about the size of the finished *Las Meninas* itself.

If the painting's composition consisted of just this foreground group—the painter, the princess and her retainers, and the dog—it would be intriguing enough. But Velázquez has included a deeper plane and thereby intensified the picture's meaning. He has defined a background plane with an open door, a wall decorated with paintings by Europe's most esteemed artists, and a mirror that reflects the faces of King Philip IV and his queen. The mirror tells us that the king and queen are in Velázquez's studio, standing where we the viewers stand. They have stopped in to chat with the painter Velázquez as routinely and casually as they might chat with the assembled nobility of Spain. The queen might be about to lean and pet this dog—lustrous, vivid, and monumental—that is not just a dog. It's a painter's statement about his skill, his stature, and position at court.

Extreme Art:
The Paintbrush as Naked Woman

One of the bad boys of the 1950s Paris art world, the French artist Yves Klein, had nude models smear their bodies with bright blue paint and then imprint themselves on canvas, all to musical accompaniment. He called the paint "International Klein Blue" and the women his "living brushes." The paintings are still displayed in museums of modern and contemporary art.

THE TOOL KIT

PAINTING

The physical qualities of a painting include its medium and scale.

Medium

medium The kind of paint used and the surface to which it's applied.

oil paint Yields lustrous colors and allows over-painting.

acrylic Dries more quickly than oil and is widely used by painters today.

tempera A blend of egg yolk, water, and pigment.

fresco Painting on a surface of plastered wall or ceiling, usually applied when the plaster is wet; an ancient and highly durable medium.

watercolor Any pigment dissolved in water. Because of its transparency, does not allow overpainting.

mixed media Refers to any mixture of different paint (and sometimes sculptural) media.

canvas A widely used painting surface because it is light, cheap, and can be rolled for easy storage. Canvas is usually stretched on a rectangular wood frame.

panel A flat wood surface.

paper A less expensive surface and therefore often used for paint sketching.

mural Any painting applied to a wall.

scale The size of a picture. An important factor in a painting's cost.

texture The feel of a painted surface to the touch.

Form

form Elements of the painting's visual or aesthetic aspect, including shape, line, color, composition, and pictorial space.

line Any point extended. Straight lines may be vertical, horizontal, or diagonal.

shape Any figure bounded or defined by line. Includes the types:

curvilinear v. *rectilinear* are curving or swirling lines versus straight and perpendicular lines).

geometric v. *organic* are triangles, squares, and circles versus floral, animal, and other natural shapes.

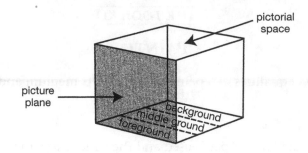

FIGURE 1.2 Pictorial space.

composition The arrangement of different pictorial elements. May involve:

symmetry or *asymmetry* is the balance or imbalance of elements left-to-right or top-to-bottom on either side of a dividing line;

movement is the direction in which figures seem to be moving in the pictorial space, or the direction in which the picture directs the viewer's eye.

foreground/middle ground/background The divisions of a picture into planes—slices of the pictorial space from front to back as it appears to the viewer.

perspective The methods of creating the illusion of depth in a flat picture.

linear perspective is the technique of making parallel lines (like railroad tracks) converge at a point.

atmospheric (or *aerial*) perspective is the technique of blurring the outlines and altering the color of distant objects.

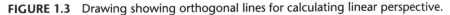

FIGURE 1.3 Drawing showing orthogonal lines for calculating linear perspective.

pattern Any meaningful repetition of an element in the picture.

unity The feeling of coherence and one-ness in a work of art. May be created by a particular visual device, such as an arch or pyramidal shape.

Color

hue The difference between red, orange, and yellow; what we generally mean by "color."

value Whether the color is light or dark.

intensity How bright or "saturated" the color is. A hue is dulled by mixing in some of its complementary color.

palette The range of colors a painter chooses in a particular work or prefers in his or her individual style.

light and dark (Italian *chiaroscuro*, pron. kyar-uh-SCHOO-roh) In illusionist painting, the pattern of light and shadow that causes objects to seem round. Defines the physical space of the scene and may be used symbolically.

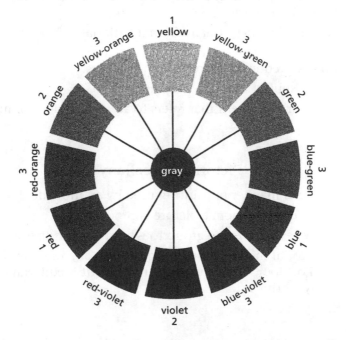

FIGURE 1.4 Color wheel. From: Dennis J. Sporre, *Perceiving the Arts,* 7th ed., (Upper Saddle River, NJ: Prentice Hall, 2003), used with permission.

primary colors The three colors or hues—red, yellow, and blue—from which other colors can be derived.

complementary colors Two hues that, taken together, combine all three primary colors. For example, orange (a combination of yellow and red) is the complement of blue, green (yellow mixed with blue) is the complement of red.

Subject

genre Scenes of everyday life.

portrait Depiction of an identifiable person.

abstract (also **non-objective, non-representational, non-figurative**) Painting consisting only of formal elements that do not depict a scene or object. Predominant in contemporary art.

religious/mythological Often employing standardized stories or scenes (for example, the "judgment of Paris" or "the death of the Virgin Mary"); may have iconographic symbols or references.

iconography The traditional or conventional symbols associated with a pictorial subject; such as the red and blue traditionally identified with the Virgin Mary.

history Historical scenes, usually from a national or heroic tradition.

landscape An outdoor scene or view in which the natural or urban environment predominates over human actors.

narrative Any subject telling a story.

symbol A pictorial element that refers to an abstract idea or meaning.

Pictorial Miscellany

style The special manner of painting used by an individual or group.

patron The client for whom a picture is produced.

audience The real or implied group to whom a painting is addressed.

mosaic A pictorial medium consisting of glass or stone tiles cemented to a wall or floor. Widely used in the ancient Mediterranean world and in Byzantine art.

THE EXPERIENCE

HOW TO LOOK AT A PICTURE

Pictures make their own world. A framed painting hanging on a wall creates its own imaginary world. It's like a window into an imaginary universe. A picture draws on and quotes from the entire world around it, the parallel "real" universe.

Get up close. When you approach a picture, step into its little universe. Put your nose up close and observe the picture as a physical object. Drink in its visual and physical properties. Sometimes you'll look into the picture so deeply that you lose sight of the image. Forget for a moment whether you're looking at an old man's face or a horse's rump. This is how the artist sees the picture—as daubs of paint before this physical stuff becomes a recognizable image.

Take a step back. Now, step back and look at the picture as a whole. You're ready to ask what the picture is about and what it means. Look at the arrangement or composition of the picture's elements: background/foreground, implied movement, dramatic action. Is there a story here? Who are the human figures? Are there symbols? Finally, how do you respond to the picture? What does it remind you of? What feelings or ideas does it stimulate in you?

Then think. Apply what you know. Study a picture in historical context. Museums can help you with wall labels and printed guides to their collections. Students can refer to histories of art. This knowledge can help identify the style or movement to which a picture belongs. It can tell you the work's patron or something significant about the artist's life and how this work fits into that story.

Respond with your own thoughts and feelings. Before you leave this picture, put all the brain work aside and meditate on it with open mind and ready feeling. Don't let the wall label or the museum guide distract you from looking and feeling. Drink in the sensory experience of the picture as a physical object and an image that speaks to you. Look at what it shows you and listen to what it says. And record that experience for yourself in a journal or notebook. This fixes the impression and helps you recall this picture as something you've become acquainted with, like that interesting person you met at last weekend's party.

THE TRADITION

medieval Chiefly Christian, full of Madonnas and crucifixion scenes, depicting a spiritual reality.

Byzantine Style associated with Greek Christianity from about 500 onward. Typified by mosaic and by gilded sacred images on panel.

Renaissance In Italy and northern Europe, invention of perspective and emphasis on pictorial unity and realistic detail; defines painting as it is most familiar to Westerners (1400–1600).

baroque For the kings and nobles of Europe, large and dramatic paintings, often of historical and mythological subjects. In Holland, the Golden Age of Vermeer and Rembrandt (1600–1700).

rococo Dreamy and nostalgic, light-hearted and naughty, a cream-puff art for Europe's idle rich and would-be idle rich (1700–1800).

neoclassicism The people look like marble statues and the buildings look like classical temples or villas. Compositions of unity, balance, and order (especially the 1700s).

romanticism Pictures of sublime landscapes and exotic or Gothic subjects. Reached its height from 1830–1860.

realism "Paint what you see!" and what you see are candid scenes of grimy workers, fleshy women, or peasants bowed by years of labor.

impressionism Sketchy paintings of urban and suburban life in brilliant colors. Though wildly popular now, impressionism was first condemned as amateurish.

modernism Challenged painting as a picture. The many "-isms" of modernism moved toward pure abstraction or pure expression.

contemporary Anything goes in the world of contemporary art. Look at the art and listen to the artist as if you had no idea what art was "supposed to be."

A Companion to Painting

Artist _____

Title _____

Date _____

Location _____

The picture's physical qualities *The work as physical object*

medium ❏ **watercolor** ❏ **oil** ❏ **acrylic** ❏ **tempera**

 ❏ **canvas** ❏ **wood** ❏ **paper** ❏ **fresco**

scale _____

The picture's formal qualities *How it strikes the eye and mind*

shape _____

line _____

color _____

composition _____

movement _____

light/dark _____

the human figure _____

pattern _____

unity _____

Subject *The scene or story*

❏ religious ❏ mythological ❏ portrait ❏ landscape

❏ genre ❏ history ❏ abstract

Meaning *Interpret significant elements*

symbolic _____

psychological _____

biographical _____

historical _____

social/political _____

Style, period, national tradition

❐ medieval ❐ Renaissance ❐ baroque ❐ rococo ❐ neoclassical

❐ romantic ❐ impressionist ❐ modernist ❐ contemporary

The artist *Individual style, other major works, biographical context*

The context *Rely on wall labels, museum guides, and handbooks*

philosophical _____

historical _____

social _____

religious _____

Your response *What you like, what you think, what you feel*

2

SCULPTURE

THE HEBREW CREATION STORY tells of a primeval act of sculpture. From a lump of damp earth, the creator God molds the first human head, the first human hands. Then, into this molded earth, God blows the warm breath of divine life. And there is Adam—sculpture as the divine art and the origin of all humanity.

Greek myth told a less exalted story of the sculptor's handiwork coming to life. In the tale of Pygmalion (as retold by the Latin poet Ovid), a sculptor falls in love with his own ivory carving of a woman's perfect form. Cursed by his own skill, Pygmalion desires his cold creation but cannot give it breath. His woeful prayer to Venus, goddess of love, is answered when she magically turns the ivory statue into living flesh.

The story of Pygmalion captures the essence of sculpture as a human art: the desire to give physical substance to human imagining, to make a body of that which we imagine. Sculpture gives physical, tangible form to ideas that reach beyond the power of our senses—the Virgin Mary's mercy, the Buddha's good-heartedness, or the companion of our dreams.

GIVING SHAPE TO THE WORLD

Sculpture possesses what a painting can only pretend to have: real, solid, three-dimensional existence. Sculptures are not in some other world that we must imagine, they are bodies in the same world as we are bodies. That's why the Renaissance master Michelangelo would have said to Leonardo, the painter: Keep your dream world of painting. I want to make firm bodies as God did when he fashioned Adam and Eve.

Sculpture is the art of giving meaningful shape to any material. For much of human history, sculptors have been most interested in one shape (or more precisely, two): the male and female forms. The history of sculpture is proof of humanity's ultimate vanity.

The earliest sculptures excavated at stone-age sites depict the female form, usually with grossly exaggerated hips and breasts. We can't be sure what these figurines meant or how they were used, but they must surely refer to childbirth or fertility. For their makers and users, these figurines provided a channel between ordinary people and the cosmic powers. The woman in childbirth who grasped this stone figure must have felt in it the assurance of the gods. The devotee who prayed before a statue of the Baal, or the hopeful lover who sacrificed to Aphrodite's image, found in the physical presence of the god a promise that their petition would be heard.

Human portraiture in sculpture often also had an other-worldly purpose. In Egypt, prominent citizens placed life-size portraits of themselves in their own tombs in preparation for their last journey—their passage through the afterlife. In Africa, bronze portraits of deceased royalty were dressed and decorated, then carried through the city as the effigy of the fallen leader.

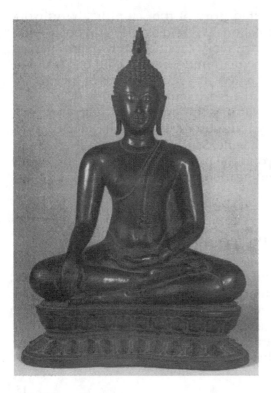

FIGURE 2.1 Seated Buddha, 13th century, Thailand. Bronze. Musée des Arts Asiatiques-Guimet, Paris, France. Copyright Réunion des Musées Nationaux / Art Resource, NY.

In Western societies, sculpture was long obsessed by the imitation of ancient Greek and Roman styles. The sculptor Bernini flattered Louis XIV by making him look like Apollo. George Washington was portrayed as the Roman soldier-farmer Cincinnatus. Napoleon was sculpted as a nude and somewhat stubby Caesar. And when the American republic celebrated its first centennial in 1876, it erected at the entrance to New York's harbor a gigantic classical goddess—a Liberty not unlike the figure of Athena that guarded classical Athens some 2,500 years ago.

Soon after 1900, European sculptors rediscovered abstraction and started on a wild, world-wide lark that will likely redefine this art for centuries to come. Artists no longer felt limited to the artful reproduction of human bodies. They were free to sculpt any form in any material, from rope and cardboard to titanium. That's the good news. The bad news is that sculpture moved out of people's daily lives into museums and galleries. Sculpture became "that thing you bump into when you're looking at a painting," grumbled one contemporary sculptor. In the 1970s and 1980s, when a sculpture was placed in a public space, it was usually some oversized and perplexing abstraction. Most people just walked past it shaking their heads—if they noticed it at all. The challenge of a new century is for sculptors to make an art that easily shares the world of a larger public.

A REAL ENCOUNTER

A SHRINE OF SORROW

The nation's capital was inexplicably deserted on a blustery Sunday morning. I was in Washington, DC for the first time in several years and chose this day to make my own initial pilgrimage to Maya Lin's Vietnam Veterans Memorial. Many thousands had already visited this massive V-shaped wall of black granite that sits half buried between the Lincoln and Washington Monuments. The wall is engraved with the name of every U.S. soldier killed in Vietnam, listed in the anguished order of their sacrifice, across a decade of U.S. involvement. The numbers of dead rise with the center of the "V", reaching a horrible crescendo and then trailing off into a quiet end. Even on this lonely morning, the wall was adorned with bouquets and mementos left by those had come to pay homage to the dead.

As sculpture, Lin's memorial is classified as minimalist, a style of geometric or modular shapes, often on a monumental scale. In fact, its abstract style made Lin's design the object of great controversy. To some political groups, this restrained memorial wasn't heroic or glorious enough. The national government finally agreed to erect a more conventional, figurative sculpture nearby, which depicted three Vietnam-

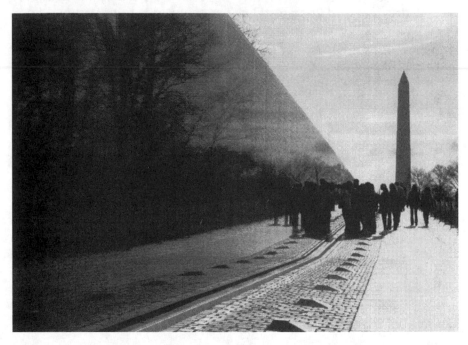

FIGURE 2.2 Maya Lin, Vietnam Veterans Memorial, 1984. Washington, DC. Black polished granite, two wings, each 246 ft (75 m) long. Photo courtesy Susanne Oll-mann.

era soldiers in cast bronze. But the polished monumental abstraction of Lin's wall has proved itself the more powerful and more popular memorial. Why is that?

To me, the Wall's silent presence is reassuring. Stand before it and look up the National Mall in one direction and you see the grassy site of loud and angry protests against the war. Turn and look across the Potomac River to Arlington and you see the white headstones of the National Cemetery, where many Vietnam veterans are buried. In its impassive stature, the Wall has outlasted the shouting and the gunfire. Lin's sprawling granite "V" makes us be silent, too, and meditate on our loss.

Extreme Sculpture: Bust in Blood

A raucous show of avant-garde art in Brooklyn in 1999 included Mark Quinn's self-portrait bust made of the artist's own frozen blood. The artist extracted his blood over many months and then molded it in the shape of his own head and shoulders. The sculpture is kept frozen in a high-tech refrigerated display case.

THE TOOL KIT

SCULPTURE

The physical qualities of a sculpture include its process, type, and material.

The Sculptural Process

modeling Molding a shape from soft, malleable material (clay or plaster) or constructing a shape from harder material (such as metal or paper). Modeling is what a child does with Play-doh or origami.

carving Cutting or chipping away material (wood or marble) from an unshaped block. Think of carving a bar of soap.

casting A complex sculptural process in which a modeled version of the desired shape is converted into a mold. Melted material (often bronze) is poured into the mold. When the metal hardens, the mold is removed, leaving a hollow replica of the original shape.

lost-wax casting The casting process in which a figure is modeled in wax; the wax figure is encased in a mold; the mold is heated to remove the wax, leaving a hollow core; molten metal (usually bronze) is poured into the mold and the mold removed, leaving a metal figure in the shape of the original wax model (also known by the French *cire perdue*).

assemblage Put together from various three-dimensional materials that retain their original form. Think of Tinkertoys.

Sculptural Types

free-standing (full-round) The sculpture stands unattached on the floor or ground, so that you can walk around it.

relief Sculpture attached to, and projecting from, a backing wall or panel; low-relief sculpture projects slightly, while high-relief sculpture projects farther.

installation A work of art erected or arranged (usually temporarily) in a particular site or exhibition space.

Sculptural Materials

ceramic Clay and other forms of workable earthen material; can be turned or "thrown" on a potter's wheel; usually painted with a glaze and baked ("fired") in a furnace, or *kiln.*

plaster Plaster is easily molded but not as durable as fired clay; often used to create a mold for metal casting.

metal Since ancient times, metals such as bronze (an alloy of copper and tin) have been melted and cast for sculpture; on a smaller-scale, soft metals (gold, silver) are worked by hand tools; contemporary sculptors use industrial methods to work steel and other metals.

stone The most ancient sculptural material of all; worked by chisel, saw, and drill.

wood Carved by a knife or turned on a mechanical lathe; wood's greatest disadvantage from ancient times was its perishability.

glass A material that must be melted, shaped, and colored in its own laborious process.

Form

form Elements of the sculpture's visual or aesthetic aspect, including shape, line, color, composition, mass (see the discussion of formal elements in Chapter 1).

space The zone surrounding a sculpture with which it may interact (turning in space, reaching out into space). In modern sculpture, sometimes described as *negative* (a void or hollow) and *positive* (a filled or protruding space).

part-to-whole Note parts as defined by differing materials, scale, or other formal qualities.

proportion The relative size and overall relationship of a figure's parts.

Sculptural Subjects

portrait A mask, head or bust, or life-size figure.

religious/mythological Often sculptural groups depicting stories or dramatic scenes—Buddha teaching under the Bo tree, Venus at her bath, or the death of the Virgin Mary.

historical Commonly depicted in relief on buildings or arches.

heroic Statues glorifying fallen leaders (think Abraham Lincoln) or political ideals (the Statue of Liberty).

abstract (also **non-objective, non-representational, non-figurative)** The preferred mode of many contemporary sculptors.

frieze Any horizontal band of sculptural decoration typically used to decorate classical buildings.

Sculptural Miscellany

mobile (also **kinetic** sculpture) A type of sculpture in which different parts move freely or are moved by a motor.

patina The coating of greenish oxidation that forms on bronze sculpture over time.

texture The feel of a sculpture's surface to the touch.

site The place where a sculpture is placed.

style The distinctive manner of sculpting peculiar to an individual or group.

THE EXPERIENCE

SIZING UP A SCULPTURE

Sculptures are bodies in space, like our own bodies. To know a sculpture, you have to do more than look, you have to engage with it. Even if it's in a glass case or hung on a wall, you have to experience it as a real thing, not a picture of something else.

Get the measure of it. Measure this sculpture as a physical object by getting close to it or walking around the work. Would it fit in your hand? Is it taller than you are? Notice the material that it's made of and visualize the process that shaped this material. Imagine what the work's surfaces would feel like if you touched them. And if the sculpture is placed in its intended site, look at its relation to this space. Does it reach out? Is it self-contained?

Next, visualize. Now step back and consider this sculpture as it strikes the eye (refer back to the "Companion to Painting," Chapter 1). Notice the sculpture's lines, shapes, and the relation of its parts to the whole. Does it seem to move? If the subject is a story, listen to the sculpture telling it.

Now think. If you have a chance, read or listen to what a guide or textbook tells you about this sculpture in historical or biographical context. Who made it? Who paid for it? Where has it been? What other objects in the world—real or artistic—does it evoke?

Finally, respond with your own thoughts and feelings. Before you leave, spend a quiet moment in this sculpture's presence. How would you like to live with this sculpture for a year? In what other place can

you imagine putting it? What would you tell a friend about it? What will people think of it in a hundred years? Record your answers in your journal or notebook as a way of enriching your experience.

SCULPTORS—
GREATS SINCE THE GREEKS

Polyclitus The classical Greek who perfected the Greek system for portraying the human form in ideal proportions.

Gislebertus One of the few medieval sculptors whose names we know. Decorated the cathedral at Autun in southeast France with a dramatic and expressive scene of God's Last Judgment.

Michelangelo A titan of the Renaissance, his *David* was a colossus that was admired as the equal of any sculpture from antiquity.

Bernini The master of the baroque age; his figures swirled and twirled with restless energy.

Canova The cold classicist; he portrayed the emperor Napoleon's family as classical deities.

Rodin Redefined sculpture with his roughened figures; his works—*The Kiss, The Thinker*—seethed with passion or anguish.

Brancusi Distilled his subjects into the abstract fundamentals of modern life; freed of feathers and a beak, his *Bird in Space* embodied the streamlined essence of speed.

Calder Inventor of colorful abstract mobiles that look grand in museum lobbies; also created large-scale "stabiles" to stand in plazas and parks.

the **minimalists** Some great, some notorious, their blank walls of steel and machined boxes are the ultimate in sculptural abstraction.

A Companion to Sculpture

Sculptor_____

Title _____

Date _____

Location _____

The sculpture's physical qualities　*The work as physical object*

process　　❒ molding　❒ carving　❒ casting　❒ assemblage

type　　　❒ free-standing　❒ relief　❒ environmental

material　　❒ stone　❒ metal　❒ plaster

scale _____

texture_____

color_____

The sculpture's formal qualities　*How it strikes the eye and mind*

shape _____

line _____

part-to-whole_____

relation to space _____

movement _____

relation to site _____

composition _____

proportion _____

treatment of human figure _____

Subject *The scene or story*

❒ religious ❒ mythological ❒ portrait ❒ heroic ❒ abstract

Meaning *Interpret significant elements*

symbolic _____

psychological _____

biographical _____

historical _____

social/political _____

Style, period, national tradition

❑ medieval ❑ Renaissance ❑ baroque ❑ rococo ❑ neoclassical

❑ romantic ❑ impressionist ❑ modernist ❑ contemporary

The artist *Individual style, other major works, biographical context*

The context *Rely on wall labels, museum guides, and handbooks*

philosophical _____

historical _____

social _____

religious_____

Your response *What you like, what you think, what you feel*

3

ARCHITECTURE

WHEN HUMANS FIRST began to build, they built mountains. Stone piled on stone, these structures rose above the river plain or the sultry jungle like a stairway to heaven. They were called ziggurat, pyramid, or "the tower of Babel." The biblical story of Babel has the moral of architecture right. In the pyramids of Egypt and Mesoamerica, humans reached beyond themselves and the dull sod where they lived, up toward the heavens and the gods. Ancient pyramids and temples were the ancestors of today's tall buildings, which no longer have a sacred purpose, but still eloquently proclaim the human power to build.

WHY BUILDINGS STAND

Architecture is the art of building—an act of constructing a shelter for human activity or a stage for human action. An army of ancient Egyptian laborers dragged mammoth stone blocks up the sloping sides of a pyramid. Medieval Irish monks piled up stones to build solitary cells for prayer. A suburban homeowner bolts together a wood deck in the backyard. These are all builders, all employing fundamental principles of architectural construction and design.

More than in any other art, design and function come before beauty and meaning in architecture. Buildings do have to stand up. So architects have had to devise forms that would first shelter dwellers from the storm, and then also give meaningful and pleasant shape to the space that they inhabit. Buildings are always partly art, partly engineering. Think of Stonehenge, the mysterious ring of huge standing blocks built in Neolithic times: Its builders had to stand those blocks on end and lift

a crossbeam to the top. This form—called the post-and-lintel—was re-
peated at Stonehenge all around the circular structure that apparently
served as a kind of astronomical temple or shrine. Symbolically, this great
circle of standing stones mimicked the great circle of the sky itself. Reli-
giously, the circle connected its builders to the unity of the sacred cos-
mos. But without the engineering know-how to move and arrange those
huge stones, Stonehenge's architects could never have said, "We are in
tune with cosmic time."

WHAT BUILDINGS MEAN

Many people can easily see that buildings stand up, but it's more diffi-
cult to see what buildings also mean. Fortunately, the world's architects
have made their statements in a vocabulary of essential forms that is
nearly universal.

The sacred mountain. The first monumentally meaningful human
structures were huge mounds of earth or stone—sacred mountains like
Silbury Hill in England that were proto-architectural since they really
provided no shelter. You could say they were all meaning and no func-
tion. Sacred mountains like Sumerian ziggurats and the Egyptian and
Mesoamerican pyramids communicated across the sacred dimension be-
tween earth and sky. They traversed that vertical axis between the ordi-
nary human and the cosmic. The biblical tower of Babel was an abortive
sacred mountain.

The column and beam. By comparison, the post-and-lintel form is
a practical and this-worldly form. It is simply a beam laid across two
columns, surely an eminently human structure. Its regularity separates
the built space of human dwelling from the irregularity of nature. It is
repeatable—the Egyptian temples covered acres—and its rows of
columns create an artificial forest, or an army of sentries, symbols of the
world's infinite multiplicity.

The tower. The tower is power—the power to see (watch towers on
the Great Wall of China), to call or command (bell towers of Christian
churches, the minarets of Muslim mosques), and to prevail (witness the
continual race in the twentieth century to build the tallest office tower).
Its sculptural kin are the monolithic column or obelisk, often erected as
a monument or memorial.

FIGURE 3.1 Dome of the Rock, Jerusalem, completed 691. Copyright Scala/Art Resource, NY.

The arch. The arch and its combinations (called vaults) are able to create a complex rhythm of connected spaces and masses. As part of a bridge or aqueduct, a single arcade can extend miles across a landscape. Combined in vaulting, the arch can swell outward and upward to enclose the most spectacular spaces that humans have ever constructed. Yet as high as it may rise above our heads, the arch always comes back to us, grounded in the solid posts that support it. Surely, the arch is one of the greatest human inventions.

The dome of heaven. The dome (in its truest form, it is a kind of vault) is the dome of heaven that defines the human world. The Roman Pantheon stands intact today because its perfection impressed even Rome's barbarian and Christian conquerors. For Muslims, the dome is a symbol of the oneness of God. Since the Italian Renaissance, Europeans have used the dome as an architectural expression of classical reason and harmony—a symbol employed by absolutist monarchs and democratic republics.

You may not encounter these symbolic forms in every building you enter, but every building you enter embodies an idea. When you observe a building, consider the geometry of mass and space, the combination of materials, the coordination of construction and decoration. Though every one of an architect's design choices must be functional, each choice is also a symbolic message. Look at a building to hear its message.

A REAL ENCOUNTER

THE MAGIC OF FALLINGWATER

Stand outside Fallingwater, designed by Frank Lloyd Wright in the 1930s, and you'll hear the trickle of a woodland stream, the chirp of birds in the rhododendron, and the buzz of visitors admiring one of the twentieth century's greatest houses. Wright never lacked self-confidence. When a patron asked Wright to build him a mountain retreat, the architect boldly designed a house that seemed suspended over the stream. At Fallingwater in southwest Pennsylvania, Wright somehow made modern materials of concrete and steel and glass merge with the riffling water and jagged layers of stone of a mountain forest.

Today Wright's Fallingwater is preserved as a testament to the imagination of its designer and the patience of Wright's patron, a department store magnate from Pittsburgh. What distinguishes this residence, of course, is its singular relation to *site*. But the vain and ambitious architect didn't submit to nature. Determined to make a bold modernistic statement, Wright designed steel-reinforced concrete trays that were anchored at one end and hung unsupported at the other (a construction called *cantilevering*).

In the house's living room, you stand literally above the water of Bear Run. Above, the trays containing bedrooms are stacked like the mountain site's irregular strata of stone. The living room is enclosed in glass walls, providing a horizontal vista into the surrounding woods and creating this building's unique connection between *interior* space and *exterior* setting. The house's unity with nature is realized in the fireplace hearth, where a stone juts from the site right into the house's floor. In the very same room, then, Wright combined materials direct from nature with modern materials—steel-reinforced concrete and mitered glass—that were stretched right to the technical limit of their capabilities.

In the spirit of modernist understatement, Wright left the interior and exterior walls undecorated. But he did employ a unifying visual motif through the building—a rectangular staircase pattern that mimicked the meandering fall of the stream was stated in stairways, canopies and roofs. And like many other classic modern buildings, this one's flaws

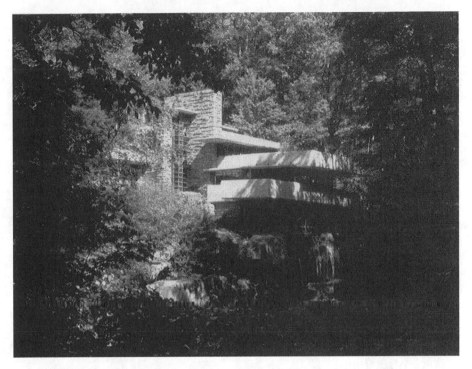

FIGURE 3.2 Frank Lloyd Wright, Fallingwater, Bear Run, Pennsylvania, 1936-1937.

are starting to show. The trays are sagging a bit, probably because Wright didn't use as much steel reinforcement as his building engineers advised. Despite its age, though, Fallingwater is still glorious and still the grande dame of modernist private residences.

THE TOOL KIT

ARCHITECTURE

Materials

masonry Any material consisting of stone, brick, or concrete.

cement Any powdered material that, when wetted, binds with stone or other hard material.

concrete A material consisting of a mixture of water, cement, and stone that hardens on drying. Concrete can be formed into curving shapes and, in modern construction, is usually reinforced with steel.

iron and glass Glass held in iron framework, as used widely in nine-teenth-century rail stations, shopping arcades, and other commercial structures.

steel The modern metal (iron with a low carbon content) of great strength and malleability widely used in modern construction.

steel-reinforced concrete (also **ferro-concrete**) Concrete strengthened by steel rods or mesh. Invented in the mid-nineteenth century, reinforced concrete is the most widely used material of modern construction.

Methods of Construction

construction The technique with which a building spans and encloses space.

post-and-lintel The most basic architectural form, in which columns support horizontal beams, as in a Greek temple.

the **arch** See below for detailed explanation.

corbeled arch Layers of overlapping stone built up and in to span a space. Not a true arch.

balloon frame A cage of wood beams; typical in American residential construction.

steel cage (also **steel frame**) A cage of welded steel beams; the method often employed in today's large buildings.

cantilever A technique of construction in which only one end of a beam or rigid horizontal member is supported, while the opposite end hangs freely in space.

The Arch

arch The architectural form in which a curving assemblage of wedge-shaped stones spans the distance between two columns or walls.

vault Any combination of arches that covers or encloses a space.

barrel vault (also **tunnel vault**) A tunnel-like series of connected arches, open on either end.

cross vault (also **groin vault**) A ceiling formed by the intersection of two tunnel vaults.

pier A masonry support, usually square or rectangular, for a roof or vault.

dome A hemispherical vault, composed of an arch rotated 180 degrees. The dome may be supported in several ways, including on a circular or polygonal drum.

arcade A series of arches carried on piers, either freestanding or attached to a wall behind.

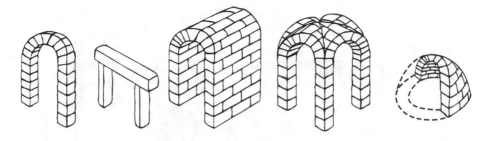

FIGURE 3.3 The arch and vaults

The Classical Temple

classical Pertaining to the buildings of ancient Greece and Rome.

frieze The band of sculptural decoration beneath the cornice.

order A style of decorating a classical temple, distinguished by the treatment of column and entablature; principal orders are Ionic, Doric, Corinthian.

cornice In classical architecture, the horizontal ledge overhanging the entablature; any horizontal projection along the top of a wall.

pediment The flattened triangle formed by the gables at either end of a classical temple; also, often decorated with sculpture.

entablature The horizontal area above a temple's columns formed by the beams; often decorated with sculpture.

portico The colonnaded porch enclosing the entrance of a Roman temple, often approached by a stairway.

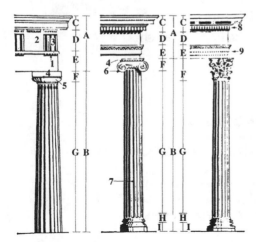

A	Entablature	I	Plinth
B	Column	1	Guttae
C	Cornice	2	Metope
D	Frieze	3	Triglyph
E	Architrave	4	Abacus
F	Capital	5	Echinus
G	Shaft	6	Volute
H	Base	7	Fluting
		8	Dentils
		9	Fascia

FIGURE 3.4 Orders of columns: (left) Doric, (center) Ionic, (right) Corinthian. Calmann & King, Ltd.

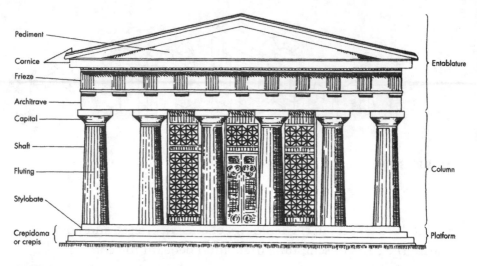

Pediment — Cornice — Frieze — Architrave — Capital — Shaft — Fluting — Stylobate — Crepidoma or crepis

Entablature — Column — Platform

FIGURE 3.5 Classical temple.

The Church

basilica The type of building most commonly used in Western Christian architecture.

nave The rectangular space of a church where worshipers congregate (Latin, ship).

aisle Passages on either side of the nave.

apse Originally the semicircular niche at the ends of a Roman basilica; in Christian architecture, the niche-like eastern end of a church, usually housing the altar.

narthex The porch or vestibule of a church.

transept The crossing arm of a cross-shaped church.

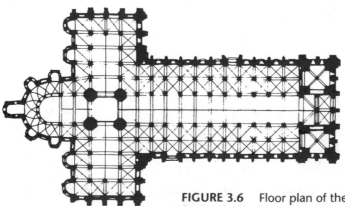

FIGURE 3.6 Floor plan of the Church of St. Sernin, Toulouse, France, c. 1080–1120.

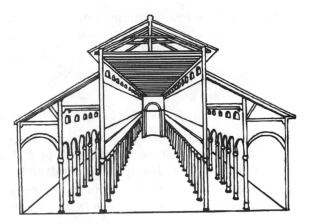

FIGURE 3.7 Section of basilica-style church.

choir The rectangular area east of (or behind) the crossing of nave and transept, where the choir stands to sing the Mass.

ambulatory A curving passageway leading from the transept aisle around the choir, giving access to the chapels.

chapel A small room or recess containing an altar and reserved for meditation and quiet worship; in a church, often an apse-like niche radiating from the transept arm or apse.

clerestory The upper section of the nave walls, usually containing windows.

buttress A supporting arm or post, usually to brace a wall, arch, or vault.

Architectural Decoration

mosaic Pictorial decoration made of colored glass and tile cemented to a wall or floor.

fresco Mural painting applied to wet plaster.

stained glass Colored glass set in metal or stone tracery.

tracery Ornamental metal or stone work, usually employed in the upper section of church windows.

relief (also **engaged**) **column** A column attached to a building wall.

pilaster A shallow relief column or pier, usually grooved with fluting and bearing a capital, that projects only slightly from the wall.

cornice An overhanging ledge, adapted from classical architecture.

molding Any shaped decorative strip. When it runs horizontally across a wall, called a **string course**.

dentil A toothlike cornice or molding, typical of neoclassical decoration.

balustrade A decorative railing.

pedimented window Window topped by an ornamental pediment; pediment may be triangular, circular, or "broken" at the apex.

Palladian window Window with an arched upper section, so-called after Renaissance architect Andrea Palladio.

Architectural Miscellany

style The distinctive ways of architectural design and decoration peculiar to an individual, group, or type of building; for example, the art deco style or Thomas Jefferson's style.

mass The weight or bulk of a building's different sections, usually discussed as they strike the eye from different elevations.

façade The front of a building.

plan The diagram of a building's floor, showing walls, columns, and other structural elements.

elevation The drawing of a building's façades as they appear from each side.

section A drawing of a building as if it were sliced through the center.

cut-away A perspective drawing with some upper sections cut away to reveal a partial view of the interior.

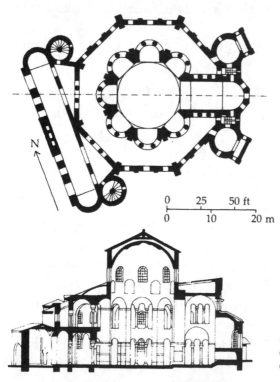

FIGURE 3.8 Plan and section of San Vitale, Ravenna, Italy, c. 527-547.

THE EXPERIENCE

HOW TO BE IN A BUILDING

A building is its own universe. Buildings are both functional and symbolic. They provide space for particular uses, but they make this space meaningful. The problem is that we're used to living in buildings without looking at them or really feeling them around us.

Size it up. Size up a building from outside first, looking at the face (or façade) it presents to you from different views. Look at how the building defines certain forms and creates masses (imagine the building as roughly carved bars of soap) in certain proportions. Note its major parts and the way they're composed into a whole. And look at the surrounding site of the building and the way the building interacts with its site. Finally, as you get up a little closer, look at the decorative elements visible from the exterior.

Go inside. As you step inside the building, look at the relation between its interior and exterior. Is the relation more continuity or contrast? How is the continuity established or the contrast created? Look up and around. Imagine, if you can, how the building was constructed and from what materials. Do the materials show? Or is there a decorative veneer that obscures the building's structure, while creating a pleasing visual environment? Here you may assess the use of painting or sculpture as decorative arts.

Wander around. As you move through a building, you are following its plan. If there are several stories, the plan may differ with each floor. Here you have to employ all your senses to experience the building as a three-dimensional space. As you wander, you will feel the relation between different rooms and floors. A good building will establish some meaningful patterns (think of Wright's stair-step falling water motif) in structure and decoration. You'll feel some continuity as well as some variety.

Touch things. Unless it's a historic structure, a building is the one material art that you're allowed to touch. So go ahead and touch the walls and the floor, especially if they're well crafted or pleasing to the senses.

Come back to where you began. Once you've been all the way through a building, come back to your starting point for some reflection. Now you may see things in the facade or the main entrance that fit

with patterns carried throughout the building. You may realize that some surprise lies behind the façade (façades can lie! Look at Las Vegas). Now you can consider the building as a whole piece, and with a journal writing or a conversation with a companion, fix this one experience of the architectural art.

ARCHITECTURE IN AMERICAN CITIES, C. 2000

Georgian A style of colonial America still much imitated. Red brick exteriors with dormer windows.

Gothic revival Originating in romanticism, the style imitates medieval Gothic-style churches and castles (towers, pointed arches, tracery, battlements).

classical or **Greek revival** Widely used in the pre-Civil War period to achieve grandeur and timelessness. Colonnaded porches and decorative elements borrowed from Greek and Roman architecture.

Beaux-Arts [boze-arr] The gilded high-society style of the later 1800s, adapted from the official French school of fine arts (*les beaux arts*). Created splendidly decorated interiors such as New York City's Grand Central Station.

Chicago School The first skyscrapers (c. 1880) constructed of an interior steel frame. On the outside, composed like a column—a base (entrance and street-level shops), shaft (several stories of regular windows) and capital (decorative top story or roof).

art deco Popular commercial style 1925–1940. Sleek curving lines defined by gleaming metal. Decorated with colorful and exotic motifs. Also called jazz, moderne, "steamship" style.

modernism or **international style** The dominant commercial style from 1950–1980. In office buildings, typically a pure glass and steel box unspoiled by decoration. May also use concrete exteriors, either smoothed or roughened (*brut* or "raw" concrete).

post-modern More colorful and eclectic than pure modernism. May incorporate elements of historical or exotic styles (neoclassical or Caribbean, for example), decorative flourishes, and playful colors. It's modernism that's been let out to play.

FIGURE 3.9 William Van Alen, Chrysler Building, New York, 1928-1930, shown in 1931 postcard. Image courtesy Jeffery Howe, Boston College.

A Companion to Architecture

Building Name_____

Architect _____

Date _____

Location _____

The building's exterior

shape _____

line _____

color _____

mass _____

proportion _____

part to whole_____

scale _____

The building's interior

space _____

plan _____

function_____

decoration _____

light _____

The building's construction

plan _____

method of construction _____

architectural forms_____

materials _____

The building's decoration

materials _____

pictorial arts ❏ mosaic ❏ fresco ❏ other

sculpture _____

music _____

The architect *Individual style, other major works, biographical context*

The style, period, or national tradition

❏ Georgian ❏ Beaux Arts ❏ Gothic revival ❏ Greek revival

❏ Chicago school ❏ art-deco ❏ modern or International Style

❏ post-modern

The context *Rely on guide books or other sources*

philosophical _____

historical _____

social _____

religious_____

Your response *What you like, what you think, what you feel*

4

MUSIC

BESIDE A SPITTING FIRE a mother croons softly to a fitful child. Asking protection from a raging storm, a clan raises its chanted invocation to the gods. Preparing for the hunt, a band of men rouse their courage with a rhythmic song. Perhaps even before humans first spoke, they were singing. From the beginning, then, music has been part of every human culture. Yet, as much as it surrounds us, music is also the most elusive art. Its history is often lost in the dying chord—unrecorded, unpreserved, but unforgettable. Maybe that's why we're always humming that tune that rattles in our head—to keep in touch with the music.

MUSIC CLASS

Music can be found in every nook of human society. In fact, we can measure the diversity of our society by the differences in its music. Think of Vienna in the time of Mozart and one thinks of palace concerts and grand operas for the emperor. But song filled the taverns as well as the palaces. The weddings of the servants in Mozart's house were just as musical as the fictional marriage of Figaro.

Compare the Top Ten lists and radio music formats that categorize music in North American cities. They divide music into types—country, contemporary adult, modern rock, Latin, rhythm and blues, jazz—that correspond to the segmented audiences of recorded music today. These types cut across the social classes and ethnic cultures of North America. They reflect peoples' connection to distinct musical traditions, their identification with different social classes and sub-cultures, and—most importantly for marketers—their different musical tastes as music consumers.

Country music, for instance, is rooted in the folk song of Appalachian mountain pioneers and the music of Western settlers. It appealed to rural ethnic whites, especially in the southern and western United States. By contrast, rhythm-and-blues grew out of the blues songs of African-American musicians around 1900 and developed alongside rock-and-roll. R&B and rock-and-roll became the preferred popular music of urban whites and blacks, respectively in the 1950s. About 1969, a teenager in any fair-sized U.S. city could flip the car radio between radio stations that played Led Zeppelin and James Brown. Somewhere else on the dial, you could also hear country music-makers Loretta Lynn and Conway Twitty too, though I personally didn't often punch that station. I learned to love country music later in life, against the demographic odds, at a Willie Nelson concert. He had long hair and braids. That made it okay.

Most readers of this guide are looking for help with the musical type called *classical* music. This single label applies to virtually the entire preserved tradition of Western music older than 1900, from the chants of medieval monks to the brooding symphonies of Gustav Mahler. In its broadest sense, *classical* also applies to "contemporary classical" or "new music"—concert music played by orchestras that breaks with classical traditions and techniques. Socially speaking, classical music's audience is better educated, wealthier, and increasingly older, to the dismay of music administrators and marketers. Because of its graying, well-dressed audience, classical bears a certain prestige or a terrible stigma, depending on one's age and point of view.

Musically, there's an intimidation factor with classical music. Johannes Brahms' music is more demanding of his audience's ear than Carlos Santana's—more complex in its form and more extensive in its range. For most of us, it's more work listening to classical music than Top 40 radio. But by investing that effort, you may end up with a lasting pleasure. I'd put Brahms' *Fourth Symphony* up against any of the latest pop hits. Though I was never country, I'm glad I learned to like Merle Haggard. Maybe it's time for you to cross over to Brahms.

THE ESSENTIALS OF MUSIC

In music, everything is relative. From the mother's lullaby to the Hebrew cantor's song, all music is based on differences in **tone** or **pitch**—whether a sound is high or low; **time** or **rhythm**—whether a sound is long or short, stressed or unstressed; and **dynamics**—whether it's loud or soft.

When you hum any tune—try "Mary Had a Little Lamb" if no one's around—you'll employ these relative elements, plus one more. Your voice will have a distinctive **timbre** (pronounced TAMB-er) that makes it

different from all others. Timbre is what makes a clarinet sound differ-
ent from a cello, even when they're playing the same note.

Underneath, at this level of fundamental definition, music is a lot
like mathematics. It's a system in which everything is measured against
something else. But on the surface, at the level of immediate experience,
we know music as melody, harmony, and rhythm.

Melody. A melody is a series of musical tones in a shape the ear can
recognize. Melody defines music in its horizontal dimension—the series
of tones stretched out in a horizontal sequence, going up and down
across a certain intervals. Some melodies don't go very far. "Jingle Bells"
repeats that same note for two measures and comes right back to where
it started. But the same insistent repetition of three rapid notes is part of
the famous motive of Beethoven's *Fifth Symphony*. Repeated across the
horizontal development of that symphony, Beethoven's concise melodic
idea gives the work its haunting character.

Harmony. Harmony is the vertical dimension—the tones played
above or below the melody. Sounded at the same time, these several
tones make a chord that support the melody. Played horizontally, har-
mony is created by the "parts"—the subordinate melodic lines of a hymn
or Christmas carol—that the altos, tenors, and basses sing below the so-
pranos' melody.

Rhythm, meter, and time. Rhythm is the pattern of stressed and
unstressed notes—the musical pulse that gets our toes tapping. Meter is
the organization of beats into regular groups or measures (indicated by
the bars of a musical score). Most music has either a duple (two-beat) or
triple meter. In written music the meter is specified as a time signature:
4/4 time means four beats per measure, with each quarter note getting
one beat; 6/8 means six beats, each eighth note counting as a beat.

Form. The essentials we've discussed so far are the building blocks
of music. Musical form is the whole building—the arrangement of a mu-
sical composition's parts into a unified and meaningful whole. Musical
forms are immensely varied (see the sample listing in this chapter's Tool
Kit). One familiar form is the A-B-A structure of popular song. An initial
melody (A) is stated in the first verse (and often repeated a second time);
a verse is sung to a different but closely related second melody (B); then
the opening melody (A) is repeated to end the song. Most musical forms
involve some pattern of statement, variation, and restatement. What's

important is to listen for the composition's different parts and their relation to the whole.

A REAL ENCOUNTER

FOUR SEASONS IN A GOTHIC LIGHT

I was lucky enough to be in Paris, by myself, and at loose ends. It was a French national holiday and the library where I was doing research was closed. Wandering the Left Bank in the early evening, I spotted a poster announcing a performance of Antonio Vivaldi's *Four Seasons* in Sainte Chapelle, the splendid Gothic chapel of the French king. I raced five blocks to the French law ministry that now occupies the palace complex and found myself nearly the last in a line of Parisians and tourists. They hustled in the latecomers and I took a seat quickly. Then, on looking up, I found myself awash in the luminous evening light of late spring, filtering through the wall of stained glass that surrounds the chapel. It felt like a miracle. Before I could catch my breath, the string ensemble sounded the opening of Vivaldi's *Spring*, probably the most familiar baroque music of all, yet in this setting just as fresh and beautiful as when it was first played in Venice. You've probably heard the buzzing bees and babbling brooks of that first movement in a shopping mall somewhere, but the mood of the other *concerti* turns more somber and at times mournful. Across all four works, melodic ideas interweave, moods darken and brighten, and the music evolves without its essential nature being altered. It was like the fading sunlight and shadow in the chapel around me, which found new colors to illuminate in fainter brilliance. When the final cadence of *Winter* echoed into silence, I might have wept from the lost beauty of it all and the chance—except for a poster on a graffiti-covered wall—that I might have missed it.

THE TOOL KIT

MUSIC, TECHNICALLY SPEAKING

Musical Scales

interval The space between two musical pitches; designated by counting up or down on the seven-tone scale from the starting point (C up to G is an interval of a "fifth").

scale Any sequence of tones in ascending or descending order of pitch.

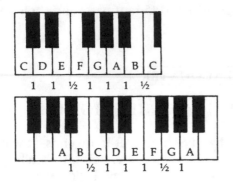

FIGURE 4.1 Major and minor scales.

step The space or interval between adjacent tones in a scale

major and minor The seven-tone scales (also called *keys*) with whole- and half-step intervals as indicated in Figure 4.1). The eighth tone in these scales repeats the first tone one *octave* higher.

chromatic A scale of all twelve whole- and half-steps in an octave (on a piano, all the white and black keys across an octave).

pentatonic A scale consisting of five tones spread across an octave

whole-tone A scale consisting of the six whole steps spaced evenly across an octave. Both the pentatonic and whole-tone scales are less stable harmonically than the seven-tone scale.

tonic The main note in a musical key.

tonal, atonal The term applied to music that is (or is not) composed in the major-minor key system and therefore based on a tonic note.

Harmony

monophonic ("one-voiced") Music consisting of a single melodic line; most of the world's musical traditions outside European cultures are monophonic.

polyphonic ("many-voiced") Music with two or more independent melodic lines (called voices or parts) that sound simultaneously.

counterpoint Really just a synonym for polyphony; the term is especially applied to Renaissance and baroque music that gave the polyphonic (or contrapuntal) voices equal value.

homophonic ("like-voiced") The most familiar kind of texture in Western music: A principal melodic line is accompanied by subordinate lines in chordal harmony, as distinct from counterpoint, in which the melodic lines move independently.

chord Any combination of two or more notes sounded at the same time, producing harmony.

The Instruments

string
woodwind　} the three "choirs" or groups of like instruments
brass

percussion

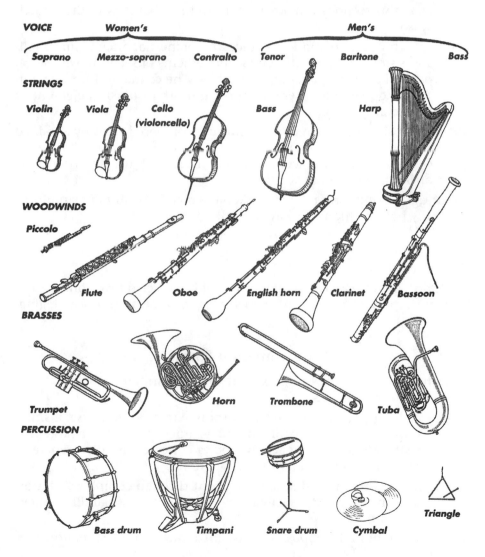

FIGURE 4.2 The instruments (not to scale). Laurence King Ltd., London, England.

Dynamics

crescendo, decrescendo "louder," "softer."

Vocal Forms

hymn A religious song of praise and adoration; a staple of Protestant Christian religious worship.

Mass The Catholic Christian liturgy set to music, consisting of five unchanging sections and other elements that change with the Church season.

cantata A big piece of music for voice and orchestra, often telling a religious story; divided into several movements or sections; with vocal parts like operatic arias and recitative. The cantatas of J. S. Bach in the baroque period were the most important musical element of Lutheran worship.

art song A song of serious musical purpose composed anew by a trained composer, rather than a folk or traditional song. Best known in German as the *Lied* [leet], pl. *Lieder* [LEED-air], usually with a text of German romantic poetry.

madrigal A song form popular in Renaissance Italy and England; usually polyphonic and always lyrical.

motet A polyphonic song form used widely in the period 1250–1750; in medieval and Renaissance versions, the upper voices often sang different texts.

oratorio For voice and orchestra, usually with a sacred text; contains the musical elements of opera but without costume or theatrical staging.

Instrumental Forms

symphony An extended composition for orchestra, usually with three or four movements.

concerto [kon-CHAIR-toh] In the baroque-era *concerto grosso*, a small group of principal instruments plays in contrast with a larger orchestra. Since the Classical period, a concerto usually involves a solo instrument playing with an orchestra.

fugue States a theme and then develops it through complex variation and embellishment, usually by counterpoint. Most familiar as performed on organ.

overture Orchestral composition that introduces an opera, oratorio, or ballet.

prelude Usually instrumental; introduces a larger work; often performed as an independent work.

sonata Musical work for solo or small ensemble. In the baroque era, commonly a trio for string instruments; in the Classical era, often a solo work for keyboard.

Theatrical Forms

opera

musical theater

(For a discussion of opera and musical theater, see chapter 6).

Music A to Z

aleatory or **chance music** Music in which significant choices in the composition or performance are left to chance or whim (from Latin *alea*, "dice").

cadence In music, a conclusion or resting place.

chamber music Music that can be performed in a small chamber or room, rather than a large concert hall. Usually involves an instrumental group no larger than eight players, with one instrument to a part, and no conductor.

chamber orchestra A small orchestra, larger than a chamber group, but smaller than a full-scale symphony orchestra.

clef The sign placed at the beginning of a staff to indicate the pitch of one line, and hence establishing the range of notes for all the lines and spaces (French, "key").

dissonance A combination of notes that violates the prevailing harmonic system, producing discord and a feeling of tension in the listener.

improvisation Spontaneously creating or adding to a musical work as it is being performed; especially prominent in baroque music and jazz.

meter The regular pulse of beats, grouped in larger units called measures (or bars), usually containing a specified number of beats per measure; see *time signature*.

modulation In music, the change from one key to another.

motif (also **motive**) A brief, often fragmentary musical idea, usually elaborated or developed in a larger composition.

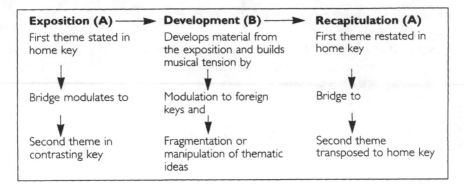

FIGURE 4.3 Sonata form.

movement In music, a section of a larger composition, such as a symphony.

notation Any system for writing music.

orchestra An instrumental group that includes stringed instruments.

orchestration The composer's choice of different instruments or instrumental groups to play different sections of the composition; an orchestration exploits the instruments' different timbres.

program music Instrumental music that describes musically an action, a scene, or some other non-musical topic. Called "program" music because the written description is printed in the performance program. Prominent in the romantic period.

serial composition (also **twelve-tone method**) The method of musical composition, devised by Arnold Schoenberg c. 1920, based on the varied combination of a series, or "row," of the twelve tones of the chromatic scale.

sonata form A three-part musical structure, employed in the Classical symphony, consisting of musical themes elaborated through an exposition, development, and recapitulation (see Figure 4.3).

staff In music, the set of horizontal lines and intervening spaces on which music is written.

tempo The "time" or pace at which music is played, traditionally designated by Italian terms (see Figure 4.4).

theme The self-contained melody on which all or part of a composition may be based.

tone (also **note**) A musical sound of particular pitch.

Largo (broad) Grave (grave, solemn)	}	Very slow
Lento (slow) Adagio (leisurely)	}	Slow
Andante (at a walking pace) Adantino (somewhat faster than andante) Moderato (moderate)	}	Moderate
Allegretto (briskly) Allegro (cheerful, faster than allegretto)	}	Fast
Vivace (vivacious) Presto (very quick) Prestissimo (as fast as possible)	}	Very fast

FIGURE 4.4 Tempo.

THE EXPERIENCE

HOW TO LISTEN—*REALLY* LISTEN

The setting or occasion. Wherever you sit down to hear a musical performance, the setting will tell you something about the music you'll hear. If you're in a concert hall or auditorium, you'll likely expect an orchestral or choral concert. If you're in a smoky bar surrounded by cool cats, you're going to hear jazz or blues. In a museum lobby, you may be expecting something contemporary and avant-garde. If you're at a wedding where a Jewish rabbi is officiating, the music will likely be different than if a Catholic priest presides. In fact, these are all great occasions to celebrate the world's rich musical heritage by your thoughtful participation.

The program. At public music performances, you'll be handed a program detailing the compositions and performers. Browse the program so you'll know something about the style and form of music you're going

to hear. There may be program notes about the music, composer, and musicians. If I'm planning ahead and I can get the recordings, I like to listen to the music beforehand. But it's also fun to be surprised by compositions that you've never heard before. Once you've heard the concert, you can evaluate the choices of the music director: Was there a common mood or character in the selections? Were they balanced in length and style?

Musical forms. Here's where a little musical knowledge can really pay off. By noting the musical form of the compositions you'll hear, you can have an idea of what to expect. Is there a piano or a violin soloist who'll play a sonata with the orchestra? Anticipating the performance usually increases my pleasure.

The performance. Now for the real thing. I try to listen to each work on the program as a self-contained piece. Melody is where to start: Listen for melodic themes, variations, and contrasting themes. Listen for the change from one part of a composition to the next—one theme giving way to another, or a theme returning to mark the end of section. Note the different instrumental choirs or voices employed in the orchestration, noting solos. Let the music play on your feelings as well as your head.

The lasting pleasure. Music is food for the soul. So when you've just heard a rich feast of music, it's worth a moment's reflection in your journal, or a conversation with companions over coffee. That's when you can set aside your handbooks and programs and really savor all the sadness, or joy, or triumph in what you've just heard.

STYLE GUIDE

MUSICAL STYLES YOU'RE MOST LIKELY TO HEAR

baroque The period of music from about 1600-1750, the time of Vivaldi, J. S. Bach, and Handel; the music is flowery and full of counterpoint.

Classical The period of music from about 1750-1810, the time of Haydn, Mozart, and Beethoven; the music embodies clarity of form and

logic of development. The *Classical* period is distinguished from *classical* music in general.

romantic From the late Beethoven to Richard Wagner, roughly 1810–1880; big sounds, emotionalism, musical stories.

modern The styles of fine music associated with the rise of the modern world, especially in the period 1910–1945; typically a lot of dissonance and very little conventional melody.

contemporary (sometimes **New Music**) A general term for avant-garde music composed in the last half-century. Often uses electronic instruments and shows the influence of atonal or serial composers from the modernist era.

popular (also **pop**) Music, mostly songs, that seeks broad popularity through popular and mass media; from Irving Berlin songs to rock-and-roll and country music; melodies and rhythms are usually simple.

jazz A type of popular music characterized by improvisation on popular melodies and a swinging rhythm; originated by African-American musicians in the early 1900s and now performed worldwide.

A Companion to Music

Name of performer or group _____

Date of performance _____

Location _____

The setting or occasion

❏ sacred ❏ secular ❏ concert hall ❏ concert chamber ❏ theatrical

The concert program

works on the program _____

composition of orchestra/ensemble _____

variety of musical forms _____

composers _____

featured soloists _____

The musical work *Its form and qualities*

the musical form _____

movements or parts_____

musical theme and motifs _____

orchestration _____

key, dynamics, tempo _____

The composer *Individual style, other major works, biographical context*

The style, period, or musical tradition

❏ baroque ❏ Classical ❏ romantic ❏ modern

❏ contemporary ❏ pop ❏ jazz

The context *Rely on program notes*

philosophical _____

historical _____

social _____

religious_____

Your response *What you like, what you think, what you feel*

5

THEATER

THE ROOTS OF THEATER must lie somewhere in the human gene. Other animals pretend—the nesting bird that feigns an injury to protect its young—but only humans don a mask and pretend to be someone else. When hunting societies act out the hunt, one hunter is costumed in the skin of the hunted animal and must act out his own sacrifice. Class societies upend the hierarchy when, for a day, the peasant plays the lord or the priest plays the pope. In this carnival drama, the lowly are exalted, and the exalted brought low. All this play-acting, this theatrical fiction, helps us give shape to our social world. Through its artifice, the play teaches us the deeper nature of reality. As a teacher once taught me, the mask conceals and reveals. The play is both pretense and deadly serious.

THE ELEMENTS OF DRAMA

The script The written dialogue and stage directions for the entire play. A script may be edited (or "cut") by the director to reduce the play's running time and clarify the action.

The plot The sequence of actions that present the story. A conventional plot will involve these parts:

exposition The setting and characters are explained.

inciting moment or *incident* The instant or action that establishes the basic dramatic conflict or poses the dramatic question.

complication or *development* The dramatic conflict or premise evolves and the suspense or tension builds in the "rising action."

climax and *resolution* When the conflict reaches its moment of highest tension and is resolved, answering the dramatic question.

dénouement (literally, "the unraveling") In the aftermath of the climax, the consequences are explored and the action comes to closure.

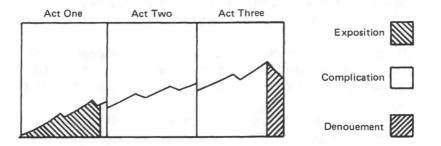

FIGURE 5.1 Hypothetical dynamic and structural development of a three-act play. From Dennis J. Sporre, *Perceiving the Arts: An Introduction to the Humanities*, 7th ed. Upper Saddle River, NJ: Prentice Hall, 2003.

Character The imaginary person who engages in the action. Characters have to seem real or convincing to the audience, even in symbolist drama. The actor's responsibility is to set aside her own psyche and body and become the entirely different person who is the character.

Staging or **spectacle** All the elements that strike the audience's eyes and ears—costume, make-up, lighting, sound, set, and stage design. Without altering one word of the script, a director and production designer can use staging to provide an entirely new interpretation of a drama.

Audience One of the most ancient theories of drama, Aristotle's *Poetics*, gave full honor to the audience's role in theater. The purpose of Greek tragedy was to engage the audience psychologically in the symbolic action and to cleanse them of their fear—the cleansing called *catharsis*.

The theater The physical place in which audience and drama meet—no more than a hillside in ancient Athens, yet necessarily a place set apart from daily life.

WHO MAKES THE PLAY?

The playwright Author of the script, including dialogue, stage directions, and other prompts for staging the drama. In the premier production, the playwright is usually present throughout rehearsal, making changes in the script, and collaborating with the director.

The actors The performers who speak the dialogue and play out the action. Actors are usually chosen (or cast) for a production by the director.

The director Governs the whole artistic side of the dramatic production. Interprets the script, chooses and guides the actors in their performance, and oversees the design and execution of the production.

The producer Arranges and directs the administrative and financial aspects of a dramatic production. Engages the director and actors, finds a theater, arranges publicity, and handles all the administrative details.

The designers (set, costume, lighting, makeup). Design and supervise the realization of the scenery and set, the actors' costumes and makeup, and the lighting. A *sound specialist* may be required to create recorded sound. The designers are responsible for realizing the director's governing vision of the production.

Stage manager or **production stage manager** Coordinates the director's intentions with the actors and the technical and design departments. Actually manages the performance on stage and back stage.

Backstage crew Executes all the required technical support behind the scenes. These include "setting" (placing) and "striking" (removing) scenery and furniture, operating lights and sound, managing the props, handling wardrobe, and so on.

A REAL ENCOUNTER

AN ANGEL OVER AMERICA

I had been reading about Tony Kushner's two-part *Angels in America* for more than two years before I saw it produced in our regional civic theater. I knew that its bleak take on sex, death, and politics in the America of Ronald Reagan was controversial. I was prepared for the obscenity, the homosexuality, and the Mormon couple, but I just wasn't ready for the angel.

At the end of Part 1, an angel falls to earth in a crash of falling plaster and rises above the play's final scene, intoning the words, "Greeting, Prophet; the Great Work begins; the Messenger has arrived." Until then, the play has been consumed by the claustrophobic misery of its principal characters—gay men afflicted by AIDS and a straight couple afflicted by religion. The angel who crashes into this play visits an America very much

in need of redemption. But the arrival is so abrupt and left so unresolved that everyone must have left the theater that night a little sick to their stomachs. I did, and I already knew how things came out in Part 2.

At its end, Kushner's play had invoked one of Western civilization's most powerful symbols, the angel who speaks for God. This is the angel who speaks to Moses, to Mary, and to Muhammad. At the end of *Angels* Part 1, a world may be beginning, or it may be ending. The angel's message may bring redemption, or divine judgment. We can't be sure. The degraded world into which this angel falls is so full of self-deception and disease—the play's naturalistic candor rubs our face in it—that both redemption and judgment seem imminent.

It's not even an angel we can believe in entirely. Kushner wanted the audience never to forget we're watching a play. He directed that the drama's "moments of magic" be staged as "bits of wonderful *theatrical* illusion—which means it's OK if the wires show, and maybe it's good that they do, but the magic should at the same time be thoroughly amazing," (see Kushner, *Angels in America, Part One: Millennium Approaches,* New York: Theatre Communications Group, 1993, p. 5.) So why does this illusion conjured on stage make its audience so queasy? Not every drama resolves its conflicts. Some leave us thinking and a little nervous.

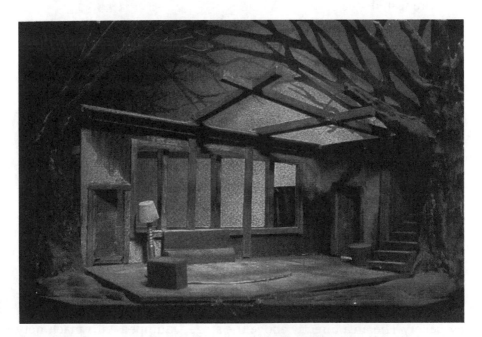

FIGURE 5.2 Modified box set on proscenium stage. Designer Michael Shugg.

<div style="text-align:center">

THE TOOL KIT

THEATER

The Stage

</div>

proscenium arch stage A stage that is framed by a large rectangular opening, as in most modern theaters.

fourth-wall The convention of realist drama that the audience watches the action as if in a room in which the fourth wall has been removed.

arena stage Staging in which the audience sits on all sides of the stage, as in a Roman arena. Also called theater-in-the-round.

thrust stage Here a part of the stage extends out into the audience, which surrounds the action on three sides.

up-stage, down-stage The rear and forward parts of the stage, respectively; so-called because stages used to incline downward toward the audience.

apron The strip of stage in front of the curtain.

orchestra pit The area in front of and below the stage where musicians are seated.

backstage The area behind and beside the stage, where the backstage crew works.

The Set

set designer Designs the entire set, from initial drawings to construction.

ground plan A map of the stage as seen from above, which locates the scenery, furniture, and other physical elements of the set.

flats Moveable scenery, made of painted cloth stretched on rectangular wooden frames.

wings On a proscenium stage, the pieces of scenery on either side of the stage that hide the backstage area from the audience.

box set A stage set representing an entire room or interior scene, with a missing "fourth wall."

scrim A curtain of thinly woven fabric that is opaque when lit from the front and transparent when lit from behind.

fly gallery The area directly above the stage, equipped with machinery that lowers or raises scenery onto the stage (scenery is "flown" in and out).

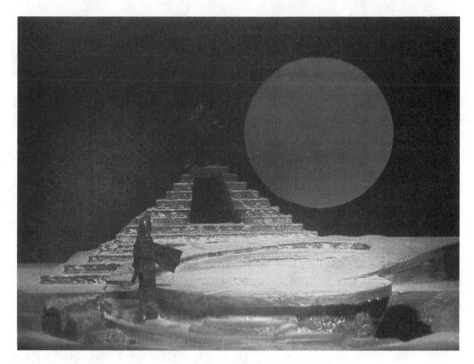

FIGURE 5.2 Model of set for *Antigone*. Designer Michael Shugg.

Theater by Degree

Broadway Large-scale commercial productions in the theater district of New York City, which—despite its ups and downs—is still the center of the theater business in North America. The corresponding district in London is the **West End**.

off-Broadway U.S. theater productions of smaller scale performed in smaller theaters than the commercial Broadway theaters. May refer to productions in theaters in or near New York's Broadway district or in other U.S. cities.

regional theater Theaters in other U.S. cities besides New York. Like off-Broadway, regional theater productions are professional theater and often produce more daring or innovative original works, such as the plays of Sam Shepard and David Mamet.

alternative theater (also **fringe** or **underground** or **off-off-Broadway**) Non-traditional theater, often performed in unconventional theater sites and in innovative style.

improvisational theater Theater in which the actors invent much of the action and dialogue as they perform.

repertory A repertory theater produces several plays in rotation, performed by the same actors and crew. A repertory company may travel to different theaters, performing alternately one of the plays in its repertoire. In the United States, usually only companies specializing in Shakespearean drama.

A Theater Glossary

act and **scene** Terms for the divisions and subdivisions of the dramatic action.

blocking Process of mapping or planning the actors' movements on stage, as guided by the director.

business The small physical actions of the actor, such as lighting a cigarette or drumming the fingers.

dramatic irony A situation where the audience (and sometimes the other characters) know something a character does not.

dramaturge Scholarly specialist in dramatic structure and theatrical production (i.e., **dramaturgy**). Long used in German theaters, dramaturges are now being employed more widely in world theater.

exposition Explanation, usually through characters' dialogue, of the events leading up to the play's opening moment and of the play's setting, when that information is not provided by the set.

farce Light comedy usually of contrived or stock situations, often with broad physical comedy (slapstick, pratfalls).

pacing Tempo or rhythm at which a dramatic production presents the dialogue and action. The aspect of directing most visible to the audience.

pantomime (also **mime**) Type of drama in which actors use gestures without words.

melodrama Originally a play in which action and dialogue were punctuated by music (the way television soap operas used to be underlined by organ chords); now any drama of extravagant emotionalism.

play-within-a-play Plot device in which characters in a drama stage a play themselves, as in Shakespeare's *Hamlet,* where a company of actors produce a play under Hamlet's direction. Often the occasion for meta-theatrical (*meta-*, meaning "behind" or "beyond") comments on the nature of play-acting and theatrical illusion.

prop Short for "properties," meaning all the individual objects used in the performance. *Stage* props are furnishings of the set, *hand* props are objects handled by the actors.

revival The re-staging of a once-popular play, usually with much of the original cast.

running time The length of time the performance takes.

satire Any play that criticizes human folly through wit and humor, usually with the intent to correct and improve.

unities (of time, place, and action) The idea of neoclassical drama, supposedly derived from the Greek philosopher Aristotle, that a drama should consist of a single unified action, set in the same place and taking place in a single day.

vaudeville Stage variety show of singing, dancing, comedy skits, and other entertainment. Popular in the period 1880–1930, before giving way to the movies as cheap theatrical entertainment.

well-made-play (French *pièce bien faite*) A tightly plotted social drama of the type perfected in nineteenth-century French theater, now often criticized as psychologically superficial.

THE EXPERIENCE

PLAYING ALONG

You've bought your ticket and the usher has directed you to your seat in the theater. You've set your expectations based on your surroundings—is it a professional Broadway theater or a makeshift stage with the audience seated on folding chairs? Then the lights go up and you're suddenly in a different world. How do you play along?

Look at the set. The stage design makes an immediate statement about this play's imaginary world. A box set leads you to expect a realistic drama with conventional rules of plausibility. A more symbolic set prepares you to suspend your disbelief and be drawn into a dramatic world of dream or myth.

Follow the plot. As you follow the action on stage, keep an eye on the construction of the plot. Notice which characters are present at a scene's beginning and end, and what has changed in the dramatic situation. Get a sense of the dramatic question or problem or conflict that underlies the action. In Arthur Miller's *Death of a Salesman*, it's an internal conflict within the principal character, Willy Loman, who confronts his failures as a father and husband. In Shakespeare's *Romeo and Juliet*,

it's the tension between the young lovers' exuberant passion and the perverse enmity between their families. One powerful force draws the lovers together, the other pulls them apart.

Respond to the characters. Focus on the fictional people engaged in the play's action. Attend to each character's individual psychology, as it's revealed by action and dialogue. You may recognize certain speeches or lines of dialogue that reveal the character. But also consider the characters in their relation to each other—in conflict or contest, or in dynamic collaboration. Remember that these are not real people, but the symbolic invention of the playwright and actors. They are pawns in a dramatic game, a play-world created to make some point or assert some truth about the real-world outside.

Observe the staging. It's easy to notice changes in the set that mark scene changes or other developments in the plot. But also evaluate the production's use of lighting and sound. The costumes and other stage furnishings may be especially important. I've seen Shakespearean comedy done as 1950s rock-and-roll, with actors in slicked-back hair-dos and leather jackets, and a villain entering on a Harley-Davidson motorcycle. The staging needs to serve the unifying idea or purpose of the performance.

Judge the acting, writing, and directing. Acting is a difficult craft because it requires a human being to become someone else, psychologically and physically. That means lying with utter credibility. In any dramatic performance, you're likely to find actors who are more convincing in their roles, or who have been especially well-cast by the director. Every acting performance is an interpretation of the character invented by the playwright. You get to judge how well the actors become their own particular someone else.

Casting and pacing are the two most visible directorial decisions. If it's a well-known play (or you've read the play and imagined it in performance), you can compare the director's overall realization of the script to other versions. You may also notice that the director has adapted or altered the playwright's version to achieve dramatic economy or some nuance in the play's meaning.

If it's a new play, you also get to judge the playwright's creation of a compelling plot and convincing characters. You should leave the theater with a clear sense of the point or truth that underlies the action, something that you carry with you back to the real world.

Engage in the theatrical experience. To be successful, theater not only requires the collaboration of artistic and technical cast. It also takes a good audience. The audience plays a part in creating that imaginary world on the stage. Give in to the theatrical fiction and play along.

STYLE GUIDE

A User's Guide to the Theater

Genres

tragedy A serious drama involving a heroic character's struggle against destiny or defeat; originated in the ancient Greek theater.

drama As a type, this term applies to any serious drama, as distinguished from comedy.

comedy A drama involving wit, humor, and ridicule, intended to provoke laughter

high comedy Involves well-born characters speaking in elevated language.

low comedy Treats low-born characters who speak in cruder language and often engage in coarse physical drama.

musical drama Any drama containing songs and musical accompaniment, in musical degree from melodrama to light opera (for more, see the chapter on Opera and Musical Theater).

Historical Types (European only)

comedy of manners Originally, light-hearted (and, some would say, light-headed) comedies of eighteenth-century England involving perplexed young lovers and foolish adults. Now refers to comedies of domestic life.

neoclassicism The revival of drama from ancient Greece and Rome, especially as pursued in France and England in the seventeenth and eighteenth centuries.

realism Dramatic style of the nineteenth century that sought truthfulness to life, instead of traditional idealized representations. Reached its European apex in the works of Henrik Ibsen and Anton Chekhov.

naturalism The attempt to represent life on-stage as it is, without artifice or idealization. Often concerned with the working classes and the downtrodden.

symbolism A style arising from European naturalism that used symbolic objects and staging methods to represent inner states of mind.

expressionism A style that represents on stage inner feelings or states of mind, often by exaggerated sets. Originated by August Strindberg and employed by German playwrights of the early 1900s.

epic theater The term invented by German dramatist Bertolt Brecht to describe an "anti-illusionist" theater. Uses on-stage narrators and other devices to distance or "alienate" the spectator.

theater of the absurd A theater of comic mockery and stripped-down staging that illustrates the absurdity of the human situation. Its masterpieces include Eugène Ionesco's *The Bald Soprano* and Samuel Beckett's *Waiting for Godot*.

A Companion to Theater

Title _____

Playwright _____

Director _____

Date of performance _____

Location _____

The stage and set

❐ proscenium stage ❐ thrust stage ❐ arena stage

The plot

initial situation_____

inciting moment_____

complication _____

climax and resolution _____

dénouement _____

The characters

major _____

minor _____

The actors

The staging

scenic design _____

costumes _____

lighting _____

sound _____

The director

casting _____

pace _____

blocking _____

The playwright *Individual style, other major works, biographical context*

The genre, type, or period

❒ tragedy ❒ drama ❒ comedy ❒ musical drama

The context *Rely on program notes, reviews, or other sources*

philosophical _____

historical _____

social _____

religious _____

Your response *What you like, what you think, what you feel*

6

OPERA AND MUSICAL THEATER

THE INVENTORS OF OPERA were a few men who met to philosophize and pluck their lutes at a nobleman's palace in Renaissance Florence. They called themselves the Florentine Camerata and in the belief that Florence would become the new Athens, they set out to recreate the tragic drama of classical Greece. The first experiments were nobly conceived, but pretty dreadful as theater. Amateur actors sang translations of Greek tragic drama in droning declamation. But the Italians loved a good show and the idea of a grand and noble musical drama appealed to aristocratic patrons in Italy. Within a century, the Camerata's first wooden productions had evolved into something we call opera. It set Europe's music lovers afire and, from Monteverdi to Mozart to Madame Butterfly, audiences have loved it ever since.

OPERA—THE GREATEST ART?

Opera has the reputation of something you either love or hate. The first obstacle to liking opera is the language. You may not understand a word they're saying up there on stage. Then there's also the social barrier. Opera audiences in North America are often stereotyped as snooty and overdressed, sort of like a tennis club where everyone has to wear whites. And then there are the definitions. Opera fans look down on lesser forms of musical theater—the Broadway musical, for example—as, well, lesser. If it's too much fun, it seems, it can't really be opera.

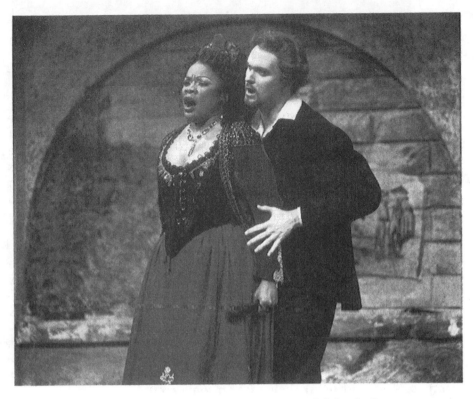

FIGURE 6.1 Denyce Graves in *Carmen*. Photo courtesy of Orlando Opera.

The snob problem is easily solved. Wear jeans to the opera. You won't enjoy the opera any less if you're comfortably dressed, and be assured, the opera company will be glad to have you (see Chapter 10 Encountering the Arts for more tips on enjoying a performance). As for definitions, Mozart didn't care. He wrote his last opera, *The Magic Flute,* for performance in the Viennese equivalent of an off-Broadway theater. What's more, he wrote it to make money.

These days, with projected super-scripts and pre-performance lectures, it's a lot easier to have a great time at the opera without having the least idea of what you're doing. But you will enjoy the experience more if you understand something of opera's character. In its different forms worldwide, opera synthesizes all the performing arts—music, theater, dance—along with visual design and spectacle into a grand feast of sight and sound. Because of its ambitious scale and technical demands, opera didn't happen everywhere. In all its forms, this kind of grand musical theater has arisen to entertain a royal or urban elite. The capitals of

early modern Europe—Venice, Milan, Paris, London, and Vienna—are still the capitals of opera (once you've added the New World upstart New York). Likewise in China, the Peking Opera (*ching-hsi*) developed in China's imperial city, where it could be supported by royal and aristocratic patrons.

Opera is also highly stylized, with set conventions of form and performance. You'll know this when a 200-pound matron plays the teenage Chinese princess in Puccini's *Turandot*. Realism is not the guiding light here. The same is true in Chinese *ching-hsi,* which represents large-scale scenes by spectacular acrobatics. In the Japanese *kabuki,* most of the plots employ characters of particular types, played by actors who specialize in those types. *Kabuki,* which developed in the commercial capital of Edo (today's Tokyo), employs sung dialogue and orchestral accompaniment, but emphasizes the voice less than either European-style or Chinese opera.

Actually, in European opera, the stress has often shifted among the art's major elements—music, drama, dance, and staging. The stage effects of Andrew Lloyd Webber's contemporary musical dramas—cats on roller-skates, crashing chandeliers, ascending helicopters—fit right into opera's tradition of bombastic entertainment. For centuries in France, for example, it was impossible to stage an opera without a ballet. Tradition and the dancers' lobby just wouldn't allow it. Wolfgang Mozart gave real dramatic tension to his operas. But his example didn't keep the later *bel canto* composers from stringing their arias on some pretty thin story lines

In the Western tradition, at least, the greatest art has always depended on one great thing—the human voice. Beneath all the spectacle and artifice, in the midst of plots sometimes trivial or interminable, an opera can send a chill down my spine with the power of one voice. To sing this music, muses one critic, is "the most captivating and beautiful thing that a human being can do on a public stage in living time."

The Voice Is the Thing

No operatic singer is born with the power to fill an entire hall with boisterous volume, or to make a character's faint dying words audible on the back row of the balcony. Achieving this range requires years of concentrated training and often full physical maturity—the reason an opera singer doesn't reach peak performance until age thirty or later.

Operatic training begins with the breath. Singers learn to create a "column" of air by expanding their lungs from the belly rather than the chest. For each note, the singer must allow the sound to resonate in "the mask"—the nasal and sinus cavities of the face. For long passages, the breath must be conserved so that the final note has all the force and conviction of the first. And, the singer must achieve this vocal feat while

also acting the part. Mimi delivers her famous dying solo in Puccini's *La Bohème* while lying flat on her deathbed.

The masters of this vocal art are international stars, who jet from one engagement to the next in the manner of rock musicians or top athletes. Opera singers are notoriously demanding: the difficult diva and the temperamental tenor are clichés of opera history. But it's hard for me to begrudge the greatest opera singers their fame and recompense for a skill trained over years of hard study. Considering what we'll pay young men to dunk a basketball, every opera singer I know is undervalued.

Operatic Voices

We categorize operatic voices by the range of notes they command and the quality (or timbre) of the voice.

soprano (S or sop.) The highest and most dramatic voice. Usually the female lead.

mezzo soprano (mez.) Often a bit lower, with a darker tone than soprano. Famous in such roles as Carmen, Bizet's *femme fatale*.

contralto (con.) Lower than soprano. Often the range for *travesti* or "pants" roles, boyish characters that are actually sung by a disguised female. Castrato roles are also often sung by a female contralto.

tenor (T or ten.) The range of opera's most famous male singers, from Caruso to Pavarotti.

baritone (bar.) Mid-way between tenor and bass, this is the range of Mozart's Don Giovanni and other notable male leading roles.

bass Bass roles are sometimes the "heavy" and sometimes comic (*basso buffo*).

A REAL ENCOUNTER

OPERA'S UNREPENTANT SINNER

Opera has the power to tell even trivial stories grandly. So when it finds a really good story, the result can knock your socks off. I always feel that way at the lurid finale of Wolfgang Mozart's *Don Giovanni* (the scene staged so effectively in the film version of *Amadeus*), when the Casanova hero is called to repentance by one of his victims. As the demons of hell howl around him, Don Giovanni utters a final "No, no, no!" and is sucked into the pit of hell.

I have to admire a character who sticks to his sins. As Mozart and librettist Lorenzo da Ponte portray him, Don Giovanni in his last days is an oddly ineffectual Casanova, though. He pursues women but never quite wins their favors. He exchanges identities with his valet so that he can watch himself woo the ladies, an odd kind of voyeurism. And he finally loses his soul over a simple peasant girl. In his last days, Mozart's hero is living on his reputation. But it's his reputation, in the end, that he's willing to be damned for.

Music people criticized Peter Schaefer for his *Amadeus,* his stage version of Mozart's last years, which was subsequently filmed by director Milos Forman. I think both had this opera psychologically right. *Don Giovanni* is about Mozart's own sense of sinfulness. Perhaps the composer expressed his own anxiety about divine judgment in music that was torn between gaiety and doom, from the opera's opening chord. The nuggets of sweetness and humor embedded in the story make its finale in Act IV all the more certain and inevitable. Even as the *buffo* valet Leporello breathlessly counts off his master's conquests, he's puzzled by Don Giovanni's restlessness. Listen to the famous seduction duet *La ci darem la mano,* where the great Don seduces a peasant girl right under the nose of her bridegroom. Mozart writes a charming song for young lovers, but gives the piece to his jaded cad of a hero. It's always the Don that I feel sorry for in this scene, not the maiden or her furious mate.

The opera's finale is a seduction scene of a different sort. The clanking Commander—the ghost of a man he's murdered in the first act—appears to call Don Giovanni to repent. The music here returns to the threatening G minor key that began the overture nearly four hours earlier. *Amadeus* would have us believe that the Commander is Mozart's own father, risen from the grave to demand his own son's repentance. But as the demons of hell wail, Leporello quails, and the Commander roars, Don Giovanni finally says "No!" He's lost his touch. He's left alone. But the Don will not be seduced by salvation. I'm always relieved that Mozart's hero remains a man of integrity—a principled sinner to the end.

Open for Debate: Operatic Re-makes... or Rip-offs?

Operagoers who took in the 1990s Broadway hits *Miss Saigon* and *Rent* noticed something familiar—like, the story. Both musicals were re-writes of Puccini's operas *Madame Butterfly* and *La Bohème* updated to the Vietnam War and heroin-chic New York City, respectively. See the opera and see the show, and debate for yourself: Which is a greater thrill? Which is greater art?

THE TOOL KIT

OPERA

Opera by Degree

opera The elevated style of musical theater as defined in the age of Mozart and dominant during the "extended nineteenth century" of about 1775-1910. It's *opera* when the performance features the operatic voice, singing frequent vocal solos, with live orchestral accompaniment. An opera's dialogue, or *libretto* (see Tool Kit), is entirely set to music (that is, "through-composed"). Usually an opera is sung entirely in the original language.

light opera, *opéra comique*, operetta, *Singspiel* [ZING-speel] All less demanding forms of operatic theater, incorporating spoken dialogue and appealing to a broader audience. Often performed in translation but still requiring operatic voices and live orchestra.

musical comedy, musical drama, musical films The Broadway-style musical, with musical numbers interspersed among spoken dialogue. The voice parts are less demanding and can be performed by singing actors. These days the actors are often equipped with microphones and the music is recorded.

An Operatic Continuum			
Mozart's *Marriage of Figaro*	Bizet's *Carmen*	Johann Strauss' *Die Fledermaus*	*Rent*
opera	opéra comique	operetta	musical
> > > > decreasing importance of the operatic voice > > > > >			

Opera Miscellany

aria A song within the opera expressing the character's state of mind or feeling. In its conventional form, the aria is musically self-contained and can be extracted from the operas, oratorios, and cantatas; commonly sung as a solo and often the occasion for virtuoso singing (Italian, "air"). Related to *da capo*.

da capo A type of aria in A-B-A form. The term means, loosely, "from the top" and was written at the end of the B section to instruct singer and orchestra to repeat the opening section.

bel canto Literally, "beautiful song." The traditional, lyrical style of Italian operatic singing. The term is also loosely applied to a type of opera from early nineteenth-century Europe that featured this smooth, sweet style, represented above all by the works of Bellini, Rossini, and Donizetti, all active in the years 1820–1840.

castrato [kah-STRAW-toh] A male singer who has been castrated as a boy to keep his voice from deepening. The greatest castratos had the range of a mezzo-soprano or contralto, combining a delicacy of tone with the power of a man's voice. They were the idols of the operatic stage until the nineteenth century, when "the knife" was abolished.

chorus The group of singers who perform in some operatic scenes, representing such roles as courtiers, townspeople, slaves, and so on. In French Grand Opera and later, the choral scenes often significantly advance the action.

coloratura [koh-lor-ah-TOOR-ah] An elaborately ornamented melody, usually to show off the skills of a soprano singer, for example in the Queen of the Night's solos in Mozart's *Magic Flute*.

ensemble Singing by three or more of the principal singers on stage in trio, quartet, or other group.

Grand Opera A style of opera prominent in nineteenth-century France that featured spectacular staging and showcased star singers. Wagner hated it and created his music drama as its antithesis.

Leitmotif [LIGHT-moh-teef, "leading motive"] As employed by Richard Wagner, a well-defined musical theme that symbolizes a character, object, or idea. A *Leitmotif* will recur in the orchestral score, developing musically and combining with other motives, all to reflect the dramatic action.

libretto The written text of an opera, composed by the librettist. The libretto is set to a vocal *score* and accompanied by the orchestral *score*.

melodrama A type of musical theater in which dialogue was recited to musical accompaniment. Now used in theater to describe the exaggerated acting style and romantic emotionalism associated with nineteenth-century romantic theater.

minimalism The avant-garde musical style, based on infinitesimal variations in a root melodic idea, that produced a new body of large-scale operas. Philip Glass's plot-less *Einstein on the Beach* (1976) was derived from minimalism and scored a monumental hit for "new" music when it was produced at New York's Metropolitan. Opera companies still frequently produce *Einstein* and subsequent operas by Glass and John Adams in a minimalist vein.

music drama The name that Wagner gave to his operas, indicating that music and drama are completely unified. Wagner objected to conventional opera, which halts the action with showy arias to display the singers' talents.

overture The orchestral introduction to the opera, usually played before the curtain rises.

recitative [ress-uh-tah-TEEV] The sections of the opera sung in a declamatory style, as distinguished from song-like arias and ensembles. Recitative helps tell the story and advance the action, as contrasted to arias, which stop the action to reveal the character's feelings. Usually accompanied by a single instrument, traditionally the harpsichord.

repertory The list of operas commonly performed. A new opera is said to "enter the repertory" as companies worldwide choose to produce it regularly.

revue On Broadway, a unified performance of musical numbers chosen from different dramas, often by the same composer or choreographer, not connected by a dramatic plot.

score The written version of the music, for voices and orchestra.

super-titles The device for projecting translations of the dialogue on a screen above the stage.

verismo [vair-EE-smoh] (Italian, "realism") A movement around 1900 in Italian opera to bring realism of setting and action to opera. Influenced the operas *Tosca* and *La Bohème* by Puccini.

THE EXPERIENCE

STORIES IN SONG

Feel the drama. The best operas and the best opera performances generate real dramatic energy. But the action is usually less realistic and predictable than in spoken drama. So scan the plot synopsis (published in the program) before each act. That way you have a general idea of the plot, and don't have to scrutinize the super-titles to follow the dialogue. Even if you don't know the story, the music will highlight the climactic moments. Listen to the music and you'll feel the drama.

Listen to the voices. Opera lives by the power of the human voice, not by the logic of its stories. So follow the dialogue super-titles with one eye and listen with both ears. Note the musical range assigned to each

role (Tosca is a soprano, Scarpia is a baritone) and the revelation of character through the music. The arias are like mini-symphonies for the voice, especially in the interweaving of voices and dialogue in duets, trios, and ensemble singing. Notice the composer's repetition and variation of melodic elements (easy enough, since the dialogue repeats, too). Let go and give in to the sound of these marvelous singers.

Absorb the spectacle. Musical theater has made its fortune by putting on a great show. These days, with touring Broadway companies, you can see all the flash and crash of *Phantom of the Opera* and other musical spectaculars, right in or near your hometown. Your local opera company's productions may be more modest, given their limited resources. So when you travel to larger cities, seize the chance to see opera in a no-penny-spared dramatic staging. With Wagner it's the stage sets and machinery, with Mozart it may be the costumes, and with Debussy's sole opera, *Pelléas et Mélisande*, it may be the lighting that creates the theatrical equivalent to the music's splendor.

Evaluate the performances. In opera, the individual performances are especially important. Listen carefully to the musical and dramatic performances of the main singers and decide which performances most impressed you vocally and dramatically. As with conventional theater, you can also evaluate the scenic design, staging, and lighting. And there's the added element of performance in the orchestra's rendition of the score.

Give in to the experience. Opera is a feast for the senses. Savor the feast and give in to the experience. Don't worry too much about plausibility of plot or psychological realism. In fact, don't try to think too much at the opera. Its truth goes right to the heart.

STYLE GUIDE

OPERATIC OPERATORS

Mozart, Wolfgang Having gotten himself booted out of the Cardinal's palace in Salzburg, the boy genius made his way to Vienna and made operatic history. His *Marriage of Figaro* is wise in the ways of love and full of comic brilliance. *Don Giovanni* is wise in the ways of lust. And the *Magic Flute (Die Zauberflöte)* is, well, magical.

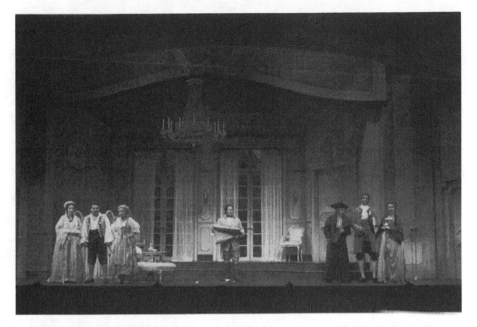

FIGURE 6.2 Ensemble number from *The Marriage of Figaro*. Photo courtesy of Orlando Opera.

Rossini, Gioacchino A master of the *bel canto* opera, best known for his comic masterpiece *The Barber of Seville* (*Il Barbiere di Siviglia*) (1816).

Verdi, Giusseppe [VAIR-dee] Along with Richard Wagner, the towering figure of opera in the later nineteenth century. His name was made with a trio of tuneful masterpieces—*Rigoletto, Il Trovatore,* and *La Traviata* (1851–1853). Then, he came out of retirement in the 1880s to set Shakespeare to music with *Otello* and *Falstaff*. If you did a poll of musicians and audiences, you'd find that Verdi's operas are the most loved among both groups.

Wagner, Richard [VAHG-ner] Artistic genius and anti-Semite, love him or hate him, there's no doubt that Wagner changed the course of opera. He married music to drama as never before, through his subtly evolving "leading motives." Though easily parodied and expensive to produce, his mythic tales of Teutonic gods and heroes lent opera a philosophical depth that it had seldom claimed since the days of the Camerata. If Verdi inspires love, Wagner's music attracts cultic devotion.

Puccini, Giacomo [POOH-chee-nee] Touched by the *verismo* movement, Puccini created one of opera's best-known masterpieces, *La Bohème* (1896), and in *Tosca,* one of opera's greatest villains, the infernal

Baron Scarpia. With recipes like these—love, death, virtue, evil—Puccini knew how to cook up a great musical show.

Gilbert, W. S., and **Sullivan, Arthur** British masters of operetta in the Victorian era. Gilbert's librettos wittily parodied British institutions, while Sullivan's scores were matched perfectly to Gilbert's pattering dialogue. Of their hugely successful "Savoy operas," you'll most likely be able to hear *The Pirates of Penzance* (1879) and *The Mikado* (1885).

Andrew Lloyd Webber and **Stephen Sondheim** Stalwarts of the contemporary musical theater. Webber is renowned for crowd-pleasing spectacle (*Miss Saigon,* an adaptation of Puccini's *Madama Butterfly*), while Sondheim's shows are more intellectual and sophisticated (*Sunday in the Park With George*, 1984, a play on the post-impressionist painting by Seurat).

A Companion to Opera and Musical Theater

Title _____

Composer and librettist _____

Date of performance _____

Location _____

The story and the roles

plot_____

principal roles _____

The musical performances

soprano_____

mezzo-soprano _____

tenor _____

baritone _____

bass _____

chorus _____

orchestra _____

The staging

the singers' acting _____

stage direction _____

set design and costumes _____

lighting _____

The composer and librettist *Individual style, other major works, biographical context*

The type or historical period

❏ opera ❏ opéra comique ❏ operetta ❏ musical

The context *Rely on program notes*

philosophical _____

historical _____

social _____

political _____

Your response *What you like, what you think, what you feel*

favorite aria _____

favorite performers _____

7

DANCE

In the movie *Footloose*, the village elders of a Midwestern town try to keep their youngsters from dancing. They suspect that dancing will encourage drinking, drugs, and unbridled lovemaking. Maybe they had seen the movie *Dirty Dancing*, which is about, well, dancing and sex. Or maybe village fathers had carefully studied the ancient Greeks whose god of the dance was Dionysus, the god of ecstasy and intoxication. From the theaters of ancient Athens to the mosh pits of rock-and-roll, humans have long sought the mind-altering ecstasy of dance—whether they find there sexual or spiritual bliss, or merely and entirely the joy of a great art.

THE POETRY OF MOVEMENT

Consider this analogy:

$$\frac{dance}{movement} = \frac{poetry}{talk}$$

A poem transforms the loose and spontaneous rhythms of common speech into the concentrated images and pulsing rhythms of extraordinary poetry. In a similar way, dance shapes the gestures and postures of ordinary movement—what we call "body language"—into a poetic statement. Dance sets this body "talk" to music and performs it as a spectacle. Dance takes something we all do every day and turns it up to the highest notch of intensity and artfulness.

In the Western world, theatrical dance is rooted in the court ceremonies from the European Renaissance and baroque eras, especially the

court of King Louis XIV of France (ruled 1660–1715). Louis was a great lover of dance and an accomplished dancer in his own right. To provide for royal entertainment, the monarch established a royal school of dance that defined a particular vocabulary and grammar of dance. The French court defined the basics of what we now call the classical ballet, with its turned-out feet and prescribed positions. Classical ballet strikes many as artificial and contrived, especially compared to the ecstatic spontaneity of folk and popular dance. But that's because it originated as entertainment for the artificial and contrived society of the French royal court.

Around the world, other royal or social élites have fostered forms of theatrical dance for their entertainment—the *bugaku* in Japan, court dances among the African Asante, and the spectacularly costumed dances of Java. The prestige of Louis XIV's court in Europe assured that the French school was widely imitated in England, Germany, and especially Russia. Ballet became such a spectacular and popular entertainment that dance schools from Moscow to Seattle still instruct children in a modified version of Louis XIV's royal ballet.

The other kinds of dance you're most likely to see in performance—in a Broadway show, for example, or in Fred Astaire movies—are treated in less detail in this handbook. They demand less specialized knowledge to watch with a beginner's eye. So what follows here will not help you improve your steps on the dance floor. It will help you watch.

ELEMENTS OF DANCE

Movement. Dance's instrument is the human body, its music is the body's poetic movement through space. In classical ballet, the individual dancer must create a graceful line and appear to dance without effort. Groups of dancers form a pageant that flows across the stage, moving in unison. The composition of these movements is designed by the choreographer but must also be interpreted by the dancer.

Music. Dance is almost always paired with music and usually the dancer's movement and gesture are matched to the music. Perhaps the greatest composer for the ballet, the Russian Peter Tchaikovsky, wrote lush romantic lines of music that easily translated into dancers' movements. By contrast, John Cage composed music for dances by Merce Cunningham without knowing anything about the dance.

Story or theme. Western theatrical dance became an independent art, not merely an interlude in the theater or opera, when it began to tell its own stories. The *ballet d'action* [BAH-lay dahk-zee-OH(n)], as it was

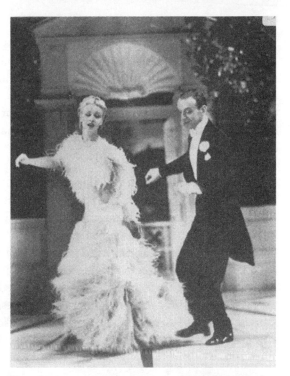

FIGURE 7.1 Scene from the movie *Top Hat* (RKO, 1935), with Ginger Rogers and Fred Astaire, choreography by Astaire and Hermes Pan, directed by Mark Sandrich.

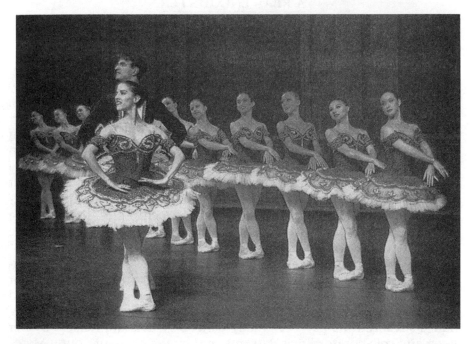

FIGURE 7.2 Principal dancers and corps de ballet in *Don Quixote,* choreography by Marius Petipa. Courtesy Orlando Ballet, Fernando Bujones, Artistic Director. Photo Michael Cairns.

called in the eighteenth century, acted out an entire scenario in several acts (usually three or four). The grand narrative ballets of the romantic age—*La Sylphide, Giselle, Swan Lake, Romeo and Juliet*—provided a coherent setting for the spectacle of dance and for the brilliance of individual dancing. In the modern era, on the other hand, story has become more dispensable.

Staging. The staging of dance—costume, set design, lighting—has much in common with theater (see the more detailed discussion in Chapter 4 Theater). In classical ballet, costume emphasizes the uniformity of the corps de ballet and enhances the pageantry of their coordinated movements. Soloists are distinguished by costume and by lighting. It's a common practice in dance that you must be able to tell the stars. The opportunity to design for dance attracted notables of twentieth-century art: Modernist master Pablo Picasso designed for Diaghilev's Ballet Russes; Japanese-American sculptor Isamu Noguchi for Martha Graham; and pop artist Robert Rauschenberg for Merce Cunningham.

A REAL ENCOUNTER

THE CONTINUITY OF DANCE

Dance is an art form that can't satisfactorily be committed to writing. The various and, today, quite sophisticated systems of choreographic notation are no substitute for a dance teacher actually showing the moves, coaching the dancers, and training younger dancers.

I thought of this when I saw a performance by the Martha Graham Dance Ensemble and marveled at their recreation and reinterpretation of Graham's famous angular dance style. This style is remembered only as it is taught by Graham's own students and dancers, passed on in that master/apprentice relationship, and recreated by artists with such respect for its artistic integrity. That's why dance still has schools in the traditional sense, places where dancers study and teachers teach a quite specific style and a repertory of dance work.

Martha Graham lived in the performance of her *El Penitente*, first performed at little Bennington College in Vermont, with sets by sculptor Isamu Noguchi, and she lived again—she moved again, she danced again—at the municipal auditorium of a Florida beach town. Young dancers realized the parts originally danced by Graham herself, by her lover and collaborator Erick Hawkins, and by the brilliant young Merce Cunningham. The dance recalls the extreme penitential practices of the Penitentes of Mexico and the American Southwest. It proceeds in the man-

ner of a medieval morality play or traveling show, with moveable props. In the end, a woman—"Virgin, Magdalen, Mother" all in one, Graham once explained—seduces a Christ-like leader and is covered by shame.

Martha Graham lived again in the way young dancers moved across a postage-stamp stage. As subsequent events have shown, that rebirth was tenuous. Less than two years after I saw the Ensemble perform, the entire Martha Graham Dance Company was dissolved. The company's failure coincided with a legal dispute over the rights to perform her works. Without a Graham company to teach and practice her method, it seemed the presence of Martha Graham might fade to a ghostly remembrance. Without dancers to carry on, the circle can be broken.

THE TOOL KIT

DANCE

Types of Dance

classical ballet Dance based on a vocabulary of movement codified in seventeenth- and eighteenth-century France.

modern ballet (also **neoclassical**) A twentieth-century variation on classical ballet based on the teaching of George Balanchine.

modern dance Various twentieth-century styles of theatrical dance, all seeking a formal dance language beyond classical technique; increasingly, modern ballet and dance have been incorporated into the repertory of major ballet companies.

jazz dance A form of dance derived from the improvisational spirit of jazz music and social dance.

folk, ethnic Any dance based on popular or ethnic traditions; sometimes performed theatrically on Western stages and also often incorporated into classical ballet.

popular or social dance The variety of dances from the waltz to swing to the twist, often featured in musical theater and film.

The Ballet Company

ballet Used in several meanings:

Generally, as "*the* ballet," the art combining dance, *pantomime*, and music in the formalized dance style that arose in baroque-era French courts.

In "*a* ballet," a particular dance work (*Romeo and Juliet*) or the music to accompany (Tchaikovsky's musical score for *Romeo and Juliet*).

As in "*the* San Francisco Ballet," a particular dance company (see below).

company (or **troupe**, or **ballet**, as in the Paris Opera Ballet) An organization of dancers who perform season after season under the same name, governed by a director and often associated with a single choreographer (as in the Paul Taylor Company).

school Dance companies often sponsor a school for training younger dancers; school graduates may be chosen to dance with the company.

choreographer Designs and directs the movements of dancers; the choreographer may create a new work from scratch or revise the choreography of an existing ballet.

ballet master/mistress Supervises training and rehearsal and assures the dancers' technical mastery of the choreography.

ballerinas and **danseurs** The principal female and male dancers of a ballet company who appear as soloists and in pairs; the first among these are the prima ballerina and premier danseur, the company's female and male stars.

coryphée, demi-soloist The second rank of dancers, likely to appear in groups of four and six

corps de ballet Ensemble dancers who appear in larger groups on stage.

costume mistress/master Costume in the dance is essential to defining mood and character; Leon Bakst actually influenced the course of modern art and design with his designs for the Ballets Russes.

production designer and **lighting designer** As in the theater, these artists help create the performance on stage; dance usually requires less scenery and fewer props.

Dance Technique

en pointe and **sur le point** French terms for the now-standard ballet technique in which female dancers rise on the point of their toe; made possible by shoes that have a hard protective toe cap.

arabesque The position in which a dancer stands on one leg and raises the other behind at 90-degree angle.

elevation, ballon Terms describing the height and springiness of a dancer's leaps.

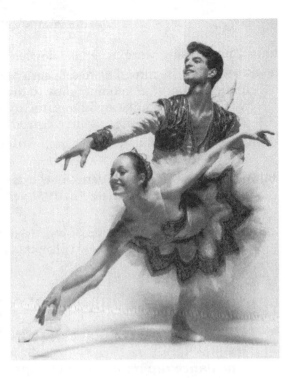

FIGURE 7.3 Pas de deux from *Don Quixote, choreography by* Marius Petipa. Courtesy Orlando Ballet, Fernando Bujones, Artistic Director. Photo Michael Cairns.

entrechats, brisés voles, and **cabrioles** Terms that describe rapid movements of the feet while the dancer is in mid-air.

fouettés [foo-uh-TAY] A crowd-pleasing set of whipping turns on one leg. The most famous example: the thirty-two *fouettés* performed by the Black Swan in the third act of *Swan Lake*.

pas de bourrées [pah duh boor-RAY] The mincing steps with which a dancer moves smoothly across the stage.

pas de deux A dance for two, male and female. In its definitive form, the pas de deux begins with both dancers together; continues with display solos by danseur and ballerina; and finishes with the pair reunited for a short conclusion.

positions The five positions of the feet that are the starting point for every move in classical ballet. Originally codified in the 1600s, they allow ease and grace of posture and movement.

port de bras [por duh BRAW] The graceful bearing or carriage of the dancer's arms and hands.

promenade The full turn a dancer makes while holding a position.

Dance Miscellany

tutu The stiff skirt worn by female dancers; it may be long or very short.

divertissement A suite of dances inserted in a ballet that bring the dramatic action to a halt and allow dancers to display their technical virtuosity (much like an aria in the opera). May be performed separately (again, like the aria) in a concert program.

swing Social form of dance associated with the swing bands of the 1930s and 1940s.

butoh (from *ankoku butoh*, "dance of the dark soul") Experimental Japanese dance form originated in 1959; characterized by its emotional intensity.

contact improvisation A type of improvised movement involving lifting, rolling, supporting, and other kinds of physical contact.

THE EXPERIENCE

MOVE TO THE MUSIC

The dance program. Set your expectations based on the performance's program. If you're seated in a large auditorium in a well-dressed crowd, you can expect to see a program from the classical ballet. If you're in a cramped, out-of-the-way theater or on a university campus, with a tiny stage, the crowd is younger and wears tattoos and pierced body parts, you're likely to see modern dance. Set your critical readiness according to the program. If you're in New York, you may see anything anywhere.

The work. The performance's program may consist of a single full-length ballet (such as *Romeo and Juliet* or *The Nutcracker Suite*) in several acts. Just as likely, there will be several shorter works in the program. In the whole works, look for a formal structure that makes them feel whole—some pattern of basic movements and a narrative or thematic unity. The concert program may also include excerpts from full-length ballet (in classical ballet they're called *divertissements*). With these, you can respond to the virtuosity of the dancing and the spectacle of the staging, without knowing the story as a whole.

The dancers. This is what it's all about. Once the dance begins, your eye will naturally go to the dancers performing the roles. Their artistry creates the performance. Observe the lines they create with arms, legs, and torsos; the pattern of movement across the stage; the relation-

ship between pairs and groups of dancers. If the dance is classical ballet, you can note their precision and flair in performing ballet's standardized movements. I almost always find a dancer that has some special talent or charm, and keep track of that performer throughout the work. The soloists often change from one performance to the next. The printed program or a spoken announcement will inform you.

The choreography and music. Every movement you see on stage has been planned by the choreographer, and sometimes even planned in unison between choreographer and composer. As you feel the rhythm and spirit of the entire ballet or dance, give credit to the choreographer. The printed program will tell you if this performance follows the original choreography (say, the Petipa and Ivanov choreography of *The Sleeping Beauty*), or if it's newly choreographed for this performance. If the dance is a new work vying for a place in the dance repertory, you're in for a real treat.

The staging. The range of costume in theatrical dance is enormous, from standard formulas of Russian romantic ballet to the exotic designs of Leon Bakst for the Ballets Russes. Dance stage sets are less elaborate than in the theater, since the stage must be left clear for the dancers. More than with other theatrical arts, the props and costumes of dance are likely to be actively integrated into the artistic presentation.

Be your own critic. Part of the fun of going to movies and plays for me is playing the critic afterwards. Being my own critic with dance is an even greater pleasure, since someone of my capacity on the dance floor can never be taken seriously. Whatever your level of knowledge, state bold and fearless opinions about the choreography and the dancers' performance! You'll remember the performance in greater detail, enjoy it in greater depth, and your true friends will know just how much credence your opinions deserve.

STYLE GUIDE

GREAT NAMES IN DANCE

Great Ballets

Giselle (1841) Original choreography: Jules Perrot. The iconic romantic or "white" ballet. A peasant maid is driven to death by a false lover

but then redeems him when she is briefly reincarnated as a spirit of the night.

Swan Lake (1877) Choreography: Lev Ivanov and Marius Petipa. Music: Peter Tchaikovsky. One of the world's best-known and most-loved ballets. Bewitched as a swan, the princess Odette can only be released from the spell by the true love of Siegfried. But Siegfried, the fool, is seduced by Odile, the Black Swan. The virtuous Odette is doomed and dances one last love duet with Siegfried before the suicidal lovers cast themselves into the lake.

Apollo (1928) Choreography: George Balanchine. Music: Igor Stravinsky. The story is strictly classical—Apollo infusing the muses with divine inspiration—but the dance is classical technique with a modern, even jazzy edge. The starting point of modern ballet.

Revelations (1960) Choreography: Alvin Ailey. Music: Traditional spirituals. A celebratory blend of traditional and popular dance that became the signature work of Ailey's company. The kind of exuberant work that won dance larger audiences in the boom years around 1970–1985.

Choreographer and Company

Marius Petipa and the Russian Imperial Ballet Petipa (1818-1910) invented the grand Russian classical style that dominated European ballet for fifty years. With the Imperial Ballet, Petipa perfected the full-length ballet as spectacle: the corps in fluid formations and the showpiece pas de deux. Petipa's *Don Quixote, The Sleeping Beauty,* and *La Bayadère* are all standards of the opera repertory.

Michel Fokine and the Ballets Russes Under the impresario Serge Diaghilev, the Ballets Russes [BAH-lay ROOS] defined modernism in the ballet. Fokine (1880-1942) preserved Petipa's classical ballet by reforming it. Fokine's *Les Sylphides* was the equivalent of an abstract painting—no plot, only dancing—but paid homage to the first romantic ballet, *La Sylphide.* His *Petrushka* melded natural movement with exotic theatricality.

George Balanchine and New York City Ballet Balanchine started with Diaghilev's Ballets Russes, but finished as impresario of an equally great company, the New York City Ballet. Along the way he transformed the grand Russian style into something new. We now call it modern ballet or neo-classicism—classical technique given a modern, experimental edge.

Dancers of the Modern

Isadora Duncan The original free spirit of modern dance. In a dance era ruled by improbable stories and stiff tutus, Duncan danced barefoot in loose flowing gowns.

Ruth St. Denis and Ted Shawn (Denishawn) From unlikely beginnings (she was a music-hall dancer, he a theology student), this couple founded the Denishawn School in 1915 and defined an eclectic and adventurous style. Their teaching and performances shaped modern dance from Martha Graham to Meredith Monk.

Martha Graham Probably the most influential figure of twentieth-century dance; she invented a visceral dance method based on the contraction and release of bodily energy. Signature works such as *Appalachian Spring* and *Letter to the World* focus on the emotional power and vulnerability of the female psyche.

Merce Cunningham One of many bold dance innovators in the later twentieth century. Cunningham choreographs by rolling dice and other chance methods, his collaborations with composer John Cage and artist Robert Rauschenberg were landmarks of avant-garde dance.

Twyla Tharp Perhaps the single most visible figure of American dance in the late twentieth century. A Graham student who helped popularize modern dance.

A Companion to Ballet and Dance

Company_____

Date of performance_____

Location _____

The dance program *Specify for each work*

title_____

choreographer _____

musical composer_____

title_____

choreographer _____

musical composer_____

title_____

choreographer _____

musical composer_____

Type of dance

❏ classical ballet ❏ modern dance ❏ folk, national, ethnic, or jazz

❏ modern or neoclassical ballet

The dancers *Soloists and roles*

Choreography and music *For each work*

The staging *Lighting, costume, and set design*

The style, period, or national tradition

The context *Rely on program notes, reviews, or other sources*

philosophical _____

historical _____

social _____

religious_____

Your response *What you like, what you think, what you feel*

8

THE PRINTED IMAGE

Prints, Photos, Digital Art

Mechanical images are only as old as the printing press—that's more than 500 years now—yet the nature and technology of the printed image has changed more radically than any other art. Three machines—the printing press, the camera, and the computer—set off those changes, each having sparked its own democratic revolution in art. Because the printing press first put artful images in the hands of ordinary people, for centuries printmaking served as a poor man's painting. When the camera was invented in the nineteenth century, it also initially served as a substitute for the painted portrait and only gradually freed itself from the aesthetic of painting. Once the camera stood on its own, it lent the printed image a new documentary truth-value. With the recent development of the computer and the digitized image, the camera's credibility has evaporated. As soon as a photograph disappears into a computer's memory, it can no longer be trusted. No one knows how it may have been manipulated when it's printed out again. But what the digitized image sacrifices in credibility, it regains in accessibility. Images are more democratic than ever, available in profusion via the Internet and other digital media. In its future history, the printed image will almost certainly change again, and probably in a direction that we can't predict for the moment.

THE ARTS OF MECHANICAL REPRODUCIBILITY

The purists fussed when computer software magnate Bill Gates bought an entire archive of historic photographs several years ago. They suspected that Gates would not display the photographs like traditional works of art, hung on walls in a well-lighted museum. They figured, rightly, that he would digitize the photos and incorporate them into Internet sites and computer software. Critics feared this would compromise the photographs' artistic value, as if art made by one set of machines—the camera and darkroom enlarger—would be corrupted if viewed through a new kind of machine—the computer.

The printed image has always lacked what the German critic Walter Benjamin called "aura"—the halo of originality and authenticity that surrounds traditional works of art. Benjamin predicted that art would lose its aura as it was subjected to mechanical reproduction. We must agree that Leonardo's *Mona Lisa* loses a bit when it's printed on the side of a trashcan. But at least there is an original painting that we can go see in Paris. There is no "original" print of an Ansel Adams photograph of Yosemite Valley. The printed image has always been mechanically reproduced, whether it was stamped out on a fifteenth-century printing press,

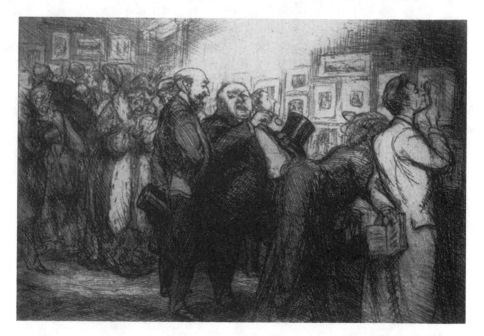

FIGURE 8.1 John Sloan, *Connoisseurs of Prints,* 1905. Etching on wove paper, 4-$^1/_2$ x 6-$^5/_8$ in. (11.4 x 16.8 cm). Cornell Fine Arts Museum, Rollins College, used with permission.

or printed in a photographer's darkroom, or stored as digitized bits of information so that it pops up on a computer screen.

So there's more than a little irony in the debate over Bill Gates' photo archive. The "original" photographs that he bought are only copies, of course, of the photographic negative. To photography buffs, however, those photographic prints are true art, each image glowing faintly with an aura of artistic originality and genius. From this nostalgic perspective, Gates' digitized versions are mere degraded reproductions. You can figure that someday digital art will have its own nostalgic fans, who will defend computerized images as "true"" art while they scorn some new printing medium as dully mechanical.

Open for Debate: Falsifiable Photographs

Is *National Geographic* magazine cheating when it digitally alters a cover photograph to move one of Egypt's great pyramids closer to another? Would you trust a nature photographer whose thundering herd of African zebras is digitally duplicated? In both cases, the digitally manipulated images are virtually indistinguishable from authentic photographs. Do these photographers violate a code of conduct by digitally altering their photographs? As an audience for these photographs, will your assumptions about the truth of these pictures change, if you can't be sure they're authentic?

THE TOOL KIT

PRINTMAKING

Engraving

engraving or intaglio (in-TAHH-glee-oh) Any printmaking process in which a metal plate is grooved or textured. The plate is inked and wiped clean, leaving ink only in the incised indentations. Plate and paper are run through a press and the paper absorbs an image of the lines or textures in the plate.

line engraving The artist presses lines directly into the plate with a hard-pointed burin. Tones can be achieved only by hatching.

etching The metal plate is coated with a resin and the artist scratches an image through the coating, exposing the plate. When the plate is bathed in acid, the acid cuts the exposed lines into the metal. The coating is removed, the plate is inked, and the print is pulled.

aquatint Similar to etching, but instead of scratching through the resin coating, the artist places drops of porous resin onto the plate. The

FIGURE 8.2 Albrecht Dürer, *The Seven Trumpets*, 1497. Woodcut on paper, 15-¹/₂ x 11 in. (39.4 x 27.9 cm). Cornell Fine Arts Museum, Rollins College, used with permission.

acid bath produces grainy areas of tonal color, similar to a wash drawing.

mezzotint An engraving process that produces tones rather than lines. The whole metal plate is first given a uniform, sandpaper-like finish. Then the artist scrapes or polishes away the grainy surface to produce gradations in tone. The burred sandpaper areas hold the ink and print black; the smoothed areas print white. In the 1700s, mezzotint allowed prints of paintings to be widely reproduced.

drypoint Here the artist uses a sharp needle that raises a rough edge (called a burr) along each line. When printed, the burr creates a velvety line.

Relief

relief In printmaking, the process in which the artist draws an image on a block of wood and cuts away the excess. When the block is inked and paper applied, only the uncut image is printed. The incised sections print white.

woodcut The basic medium of relief prints. The artist carves a plank of wood, which is then inked and printed. In color woodblock printing, a different block is carved for each color.

wood engraving The artist incises the end grain of a block of wood, making a much finer line than the wood cut.

linocut Same as a woodcut, except using a linoleum block.

Other Processes

lithography A process that works with grease and water. The artist draws with a grease crayon on a "stone" (originally a block of limestone, now a zinc plate). The stone is wetted and then inked with greasy ink. The ink sticks only to the drawing and runs off the wet stone.

monotype The artist paints directly on a plate, from which a single print is pulled; hence, only one print can ever be made of the image.

silk-screen (also **serigraphy**) The artist creates a design by masking or stenciling parts of a fabric screen. Ink or paint is brushed through the screen onto paper.

graphic transfer The transfer of an image from one medium to another, as when a magazine photograph is transferred to a painting. Now done photographically, transfers were first made by soaking a page with lighter fluid and rubbing the image onto a different sheet of paper.

Printmaking Miscellany

burin Any sharp-pointed tool for engraving.

cancel To deface or destroy a plate so that it can't be used again. Important in assuring a limited edition.

edition The number of prints from a plate authorized by the artist for distribution, usually numbered as 25/50 (the twenty-fifth print of a total of fifty). Assures the collector that the artist won't duplicate this image indiscriminately.

format The size and shape of the plate or block and, therefore, of the printed image.

hatching (also **cross-hatching**) Fine lines in a lattice pattern that create tonality in an intaglio print.

proof A test impression. Usually, a proof is pulled at each significant stage (or state) of the printmaking process.

reproduction A copy usually made by someone besides the artist, these days usually by a photographic process.

stencil A cutout that controls the application of ink to areas of the print surface (as in silk-screening).

<div align="center">

THE TOOL KIT

PHOTOGRAPHY

The Film

</div>

film Photography starts with the film—any medium (usually celluloid) coated with a light-sensitive emulsion (in black-and-white film, silver halides). The film is loaded into a camera and exposed to light, producing a negative image.

format Film is distinguished by the size of negative. The most widely used format is 35 mm.

speed The sensitivity of a film's emulsion to light. Measured on an ASA or DIN scale.

The Camera

camera Any device consisting of a box and a lens that focuses an image. Based on the *camera obscura* (Latin for "darkened chamber"), a Renaissance discovery: When light passes through a pinhole in the curtain of a darkened room, an inverted image will be projected on the back wall.

viewfinder Any peephole device for seeing what the camera sees.

rangefinder camera The type commonly used for casual snapshot photography; has a viewing system separate from the camera's lens. Most use 35 mm film, and today's electronic versions have automatic focusing devices.

SLR (single-lens-reflex) The workhorse 35 mm camera used today by most serious photographers. An arrangement of mirrors allows the viewfinder to look through the lens, easing the problem of framing and focusing the shot. When the shutter is pressed, the mirror snaps up (a "reflex") and allows light to expose the film behind.

medium- and **large-format** Any camera that uses a larger negative than 35 mm (4x5 and 8x10 inches are standard). The cameras are heavier and the film more expensive, but the resulting photographs contain more visual information.

view camera A large-format camera that allows the photographer to view directly through the lens. The body of a view camera often has a

flexible bellows that allows the lens to be angled differently relative to the film plane.

shutter The door inside the camera that opens when you press the shutter, exposing the film to light.

aperture In 35 mm cameras, the iris-like diaphragm that widens and narrows. The smaller the aperture, the greater the depth-of-field.

depth-of-field Within the lens' field of vision, how much of the space will be in focus. With shallow depth-of-field, only a narrow plane (usually the foreground) is in focus. With "deep focus" you can see everything from foreground to background. Controlling depth-of-field allows the photographer to dramatize certain elements in the image.

f-stop (f-number) The camera setting that sets how wide the aperture opens and therefore how much light reaches the film. The numbered "stops" or settings (4, 5.6, 8, 11) are actually abbreviations for geometric ratios. The higher the number, the smaller the aperture.

shutter speed The setting that sets how long the shutter opens and therefore how long the film is exposed.

lens The system of ground and polished glass lenses that focus an image on the film; either contained in or attached to the camera. Lenses are identified by their focal length (50 mm, 150 mm), the distance at which they focus far-away objects.

filter Any film or glass, usually attached to the lens, that absorbs some light wavelengths reaching the lens and the film. Filters can dramatically alter the character of the image.

mirror
moves up
when shutter
is released

pentaprism
corrects
image

mirror returns
instantly to
viewing
position after
exposure

FIGURE 8.3 The single-lens reflex (SLR) camera.

The Darkroom

darkroom A room equipped with the trays, chemicals, an enlarger, and other equipment necessary to develop film, print on paper, and develop the print. Parts of the process must be done in the dark or under special light.

developing The process by which the exposed film or paper is bathed in chemicals to bring up the image. Requires developer, fixer, and water.

enlarger The large machine with a bright light and lens that projects a film image downward onto photographic paper. The enlarger is like a reverse camera, creating a positive image of what the camera saw and recorded on film as a negative image.

photographic paper Paper coated with light sensitive chemicals. When exposed to light through the enlarger and developed, different papers produce black-and-white or color images.

printing The whole process of exposing the paper to light and developing the image on paper. May involve many ways of enhancing, altering, or manipulating the film image.

contact print Print made by laying the negative directly on the paper, without using an enlarger.

gelatin silver print Print made on gelatin silver paper, the most common type of black-and-white paper. The paper's emulsion consists of a gelatin containing light-sensitive silver compounds (silver bromide or chromide).

multiple exposure Exposing a single piece of paper to several film images.

burning and **dodging** Using a masking device to lighten or darken some parts of the printed image.

solarization Re-exposing a negative or print to light during processing, to create unusual and unpredictable reversals of black and white.

Color Photography

Modern color photography dates to 1935, when inventors developed a film coated with three different emulsions—one for each of the three primary colors. Developing this film remains a complicated process that most professional photographers don't bother with. They send it to a color lab, just like you do.

color reversal The standard color film, so-called because in the first stage of development the emulsion turns black and in a second stage, it's reversed to produce color.

Polaroid A special kind of color film that develops itself instantly after exposure. Invented in 1947 by Edwin H. Land.

dye transfer A printing process that requires a special film and paper. Valued for the high quality of its color reproduction but no longer used.

C-print The standard method of color printing for casual photography and many professionals. Over time, the C-print colors can fade because of instability in the emulsion.

Cibachrome A unique color printing process prized for the brilliance of its color and the permanence of the print. The dyes are actually embedded in the paper itself rather than in a coating of emulsion.

Photographic Genres

pictorialist A school of early photography that sought to make the photograph look like a painting. Preferred women subjects in garden or Greek settings.

straight The definitive genre of modern photography. The photographer pointed the camera at something beautiful or significant, and let the image speak for itself. Justified photography as an art in its own right.

documentary Really a sub-genre of straight photography, documentary photography is more politically engaged. It provides a visual document of social and political reality, often with sympathy for the oppressed.

photojournalism Photography in service to journalism, practiced by newspaper and magazine photographers who document events to inform the public.

Photographic Miscellany

photomontage A collage of photographic images.

framing Controlling the borders of the image to create an interesting composition.

cropping Changing the borders of an image during printing.

contrast In black-and-white photography, the difference in tone between the bright and dark areas. High contrast means very white whites and black blacks; low contrast lots of grays.

THE TOOL KIT

Digital Images

The terms and descriptions below may be completely outdated by the time you read this. That's how quickly the technology of digital image-making is changing. But the first decade has produced an entirely new category of art that must be printed and that we call **digital** or **computer** art.

digital and **analog** The two different ways that printed images are "stored." An analog image is stored as light, with differences in color and lightness/darkness, recorded by the light-sensitive chemical emulsion on the film or paper. A digital image converts and stores this visual information into electronic form (essentially as millions of 1s and 0s). When the digital image is displayed on a computer screen or printed, the eye re-converts it to analog—black, white, and color.

CCD (charge coupled device) The computer chip in a digital camera that converts light to digital information.

pixel (from "picture element") The "dot" in a computer image. The density (or resolution) of pixels determines the digital image's quality.

resolution A measure of the density of pixels in a digital image, expressed as a ratio of vertical by horizontal. A low resolution image of 640 x 480 pixels contains less visual information than a 1600 x 1200 image. A digital image's resolution has nothing to do with its size. A 640 x 480 image can be printed as a snapshot or a wall poster. The snapshot will be OK, but the poster will look crummy because you'll be able to see every pixel. The disadvantage of high-resolution images is the memory space needed to store them and the time to transfer or download them. In storing an image, resolution is determined by the storage capacity of the CCD. In displaying an image on a screen, it's limited by the computer monitor's resolution. In printing an image, resolution is limited by the number of dots-per-inch (dpi) the printer can produce.

digital camera Any camera that stores the image directly to a CCD or a computer storage disk.

scanning Any process of reading an analog printed image (a conventional photograph, for example) and translating it to a digital image.

interactivity The ability of a digital image or program to respond to the viewer-user.

virtual reality A multisensory digital experience of image and sound that seeks to reproduce an entire sensory experience. Often interactive.

THE EXPERIENCE

PICTURES, PICTURES EVERYWHERE

Because we're bombarded constantly with printed pictures in the commercial culture, it takes some real effort to look carefully at this kind of image. Normally we're just paging through the magazine or speeding by the billboard without a second thought. The aesthetic experience of the printed image might look like this:

The process. In a museum or gallery, read the label or description to learn what process of image-making produced this image. If it's a print, look at the qualities of the image as they relate to that process. For example, etching produces layers of fine lines, whereas silk-screen produces flat areas of bold color. The process makes a difference.

The image. Study the image with the critical vocabulary you've learned from painting. Consider the artist's choice of subject. Look for composition, line, light and shadow, color, and the other formal elements of visual communication. The printmaker may have used collage to add a physical element to the print. The black-and-white photographer may have manipulated contrast or focus to control the image's meaning. Images may have been combined or manipulated in the darkroom printing process. The digital artist may be combining images digitally in a seamless montage.

The meaning. In the printed image, the meaning depends a lot on the process. You can interpret a print with most of the same expectations as a painting. The painting is a fictive and hand-made image. A photograph is a different kind of beast (philosophers would say it has a different *ontological* status, a different quality of being). Photographers are physically present at the events they record, whether it's the misery of a drug addict or the violence of war. They are participants as well as observers. Their cameras record those events mechanically and our attitude toward the photograph reflects its special status as witness and testimonial. So as you look and reflect, consider the photograph's character as documentary and journalistic truth. Then throw all those expectations out the window when you get to digitized images and digital art. Since the digital artist has complete freedom to manipulate the image, you may have to revert to your meaning filters from fictive images. Or you may reserve judgment until digital artists and critics devise a new critical language appropriate to this new beast.

Your response. The most important questions remain: Do you like it? Why or why not? Do you believe it? Why, or why not? What kind of memory does it leave with you as the observer, or audience, or consumer—whatever your ontological status is?

MASTERS OF THE PRINTED IMAGE

Albrecht Dürer (German, 1471-1528) The first great printmaker. He used printed images to illustrate the contentious religious and philosophical ideas of the Renaissance and Reformation.

Rembrandt (Dutch, 1606–1669) He indulged his interest in subtle effects of light and dark by reworking his favorite etchings again and again.

Katsushika Hokusai [hoh-koo-SEYE] (Japanese, 1760-1849) Along with Ando Hiroshige, a master of the Japanese color wood block print. His bold designs profoundly influenced Western painting.

Honoré Daumier (French, 1808–1879) His greatest works—caricatures of the powerful and gripping scenes of injustice—were drawn quickly on lithographic stones and printed in cheap Parisian newspapers.

Alfred Stieglitz (North American, 1864–1946) The inventor of modern photography. His most famous images—a horse-drawn trolley snowbound or immigrants crowding a boat's steerage compartment — found beauty in straight scenes of urban life.

Edward Weston (North American, 1886–1953) If Stieglitz invented modern photography, Weston invented photography as modern art. He found abstract beauty in the curve of a female nude, a bell pepper, and California dunes.

Dorothea Lange (1895–1965) Perhaps the greatest of the American Depression-era photographers. She documented the anguish of poverty and unemployment.

A Companion to the Printed Image

Artist _____

Title _____

Date _____

Location _____

The process *Rely on museum labels and guidebooks*

❏ line engraving ❏ etching ❏ woodcut ❏ lithography

❏ black-and-white photography ❏ color photography ❏ digital art

The image as physical object

format _____

paper _____

The image's formal qualities *How it strikes the eye and mind*

shape _____

line _____

color _____

composition _____

movement _____

light/dark _____

the human figure _____

pattern _____

unity _____

Subject *The scene or story*

Meaning *Interpret significant elements*

symbolic _____

psychological _____

biographical _____

historical _____

social/political _____

The artist *Individual style, other major works, biographical context*

The context *Rely on wall labels, museum guides, and handbooks*

philosophical _____

historical _____

social _____

religious_____

Your response *What you like, what you think, what you feel*

9
MOVIES

Movies are the myths of the twentieth century—a collective experience celebrating the characters and stories that define our culture. A movie audience sits transfixed in the darkened theater much as listeners to ancient myth and tale sat around a guttering fire or lamp. Today we watch Mel Gibson and Danny Glover act out their absurdly comic screen adventures—escapes from exploding buildings and the like—with something like the entranced delight that a native American clan found in a trickster tale of Old Man Coyote. They used words for their stories, we use celluloid images.

THE NOVEL OF THE TWENTIETH CENTURY

In form, at least, it's more proper to compare narrative film to the novel, that marvelous invention of the eighteenth century that still generates compelling stories. Like the novel, the movies began as a popular medium that soon attracted some highly artful practitioners. D. W. Griffith's epic films *Birth of a Nation* and *Intolerance* not only produced pathbreaking technical innovations, they told stories on a grand scale, with high ambition to historical scope and moral truth.

Film making grew technically more sophisticated until, with the advent of sound, it could project a fully articulated aesthetic experience that people felt was highly artful. By the 1940s the movies were stimulating critics and theorists to explain this experience in a critical language that was peculiar to the art of film. If we review the history of the other arts, we discover a similar transition from handicraft to high art, coarse entertainment to exalted culture. This last chapter in a guide to

high culture treats film making as the youngest human art to achieve that standing.

Among the other arts, especially the storytelling arts, movies are an intriguing hybrid. Unlike the narrative arts of myth and the novel, the movies tell a visual story. It's not that the words aren't important. It's that words are overtaken by the powerful forward momentum of those images. During the filming of *Star Wars,* Harrison Ford is supposed to have complained about the wooden script. "Real people can't talk this way," he groused to director George Lucas. But it didn't matter. Lucas was telling his adventure story in pictures and it worked even though the dialogue was so stilted that it seemed to hang over the characters like comic strip balloons. Of course, that's just the way that silent films presented dialogue—as written inter-titles between the images. *Star Wars* and similar cartoonish adventure films are a throw-back to the first great narrative films.

Myth had to be transmitted and preserved through the spoken word. It was a poetic medium. Novels were written and printed. They're a literary medium. Only in the twentieth century did we develop the technical means to tell great stories in pictures. If you're going to be an intelligent and critical movie viewer, you have to look behind the story at the pictures.

WHO MAKES A MOVIE?

Actors Usually the most recognizable but not always the most important people involved in making a movie. They interpret the script under the director's guidance.

Director Supervises everything that happens with the camera and in front of the camera. Compared to the classical Hollywood system before 1960, today's directors usually have greater creative control over casting, screenplay, and other elements of the production.

Cinematographer (also **director of photography**) The person responsible for lighting and mise-en-scène, so that the director gets the desired shot.

Producer The people a movie really starts with, who choose a script and director, contract for actors and all the other creative participants, and oversee the movie as a financial and legal undertaking.

Screenwriter Author of the written text of dialogue and action. Movie scripts are often re-written several times and often by different people.

Production designer Governs the whole "look" of the movie, including costumes, makeup, sets, props—everything except the physical landscape.

Editor Collaborates with the director in arranging the sequence of shots and scenes in the desired order. Editing gives the movie its visual and narrative rhythm and sequence.

Composer Writes the music that is added to the film soundtrack after filming.

Special effects artist Supervises the creation of special visual effects. These may be large-scale stunts or apparatuses, or actions achieved with miniatures, models, and computer-generated images.

A REAL ENCOUNTER

A SHOT HEARD 'ROUND THE FILM WORLD

Most people don't pay much attention to the title sequence at the beginning of a movie. It's a signal that the movie starts in a minute. Find your seats and pass the popcorn. The overture in an opera once served the same purpose: It told the rowdy audiences that the singing—the real music—would soon begin.

It takes a self-confident film maker to start the movie now—with the first shot. That was the virtuoso's challenge in Orson Welles' masterpiece *A Touch of Evil*. It started with the longest and most famous opening shot in movie history. From a close-up of a kitchen timer attached to a car bomb, the camera pans left for a deep-focus shot of a couple approaching down a long gallery. The deep shadows reveal the film's style as *film noir* and the sinister bongos in the soundtrack keep reminding us of the ticking bomb. The camera cranes up to see a man plant the bomb in a car that belongs to our couple. From there, still without a cut and with the titles rolling past, the camera cranes and dollies back to follow the car's progress along the midnight streets of a Mexican border town. The camera catches a different couple. They're played by the stars Charlton Heston and Janet Leigh, whose credits have just rolled past, and they approach the border crossing along with the car. Banter with the U.S. border guard reveals the stars as newlyweds, the Leigh character a blonde American and the Heston character a high-ranking Mexican police investigator. When they pause to kiss, an explosion interrupts them and—now, finally, after one long take of nearly three-and-a-half minutes—the film cuts sharply to the burning car.

In that brilliant first long shot of *A Touch of Evil*, Welles established the film's generic style, he set in motion the entire plot, and he set off the film's fundamental thematic tensions: blonde v. swarthy, Mexican v. "American," integrity v. corruption, civilized order v. primitive chaos. It's not the first page of a novel, it's the entire first chapter.

I saw Welles' masterwork in a 35 mm print after it was re-released in 1985. Film maker Robert Altman must have seen it, too, because his smart and cynical film *The Player* pays homage to *A Touch of Evil*. Altman's title sequence is a single take twice as long as Welles', showing us the vacuous and self-absorbed world of a Hollywood film studio. Among the dozens of characters we encounter through all the dollies and cranes of this long take, two characters are discussing famous long shots, including Welles' opening shot in *Touch of Evil*. In *The Player*, it's not a bomb that goes off, it's a postcard, but a fateful action is started all the same, started with Altman's own cinematic bow to Orson Welles.

THE TOOL KIT

THE MOVIES

Camera Work

the shot The basic unit of film—what the camera sees and records in one "take" or continuous exposure of film. *Long* shot (far away, showing us a large area), *medium* (the actors from head to knee), and *close-up*. (For more, see below.)

camera angle High-angle (camera looking down), low-angle (looking up), and straight on.

camera movement *Tilt* (up or down) and *pan* (swivel side-to-side). For a *tracking* or *travelling* shot, the camera is set on a dolly and moved along tracks. *Crane* shot—camera is attached to a crane to swoop out over and above the action. The jerky but compelling *handheld* shot is common in documentary; the *Steadicam* is a patented moveable frame attached to the camera operator's body that smooths out handheld shots.

lens Controls how much of the action is in view and in focus. A deep-focus lens allows us to focus far into the background of a shot.

lighting Important in all film and *really* important in black-and-white film. A whole genre of Hollywood—film-noir—is defined largely by a characteristic lighting style.

FIGURE 9.1 Banquet scene from *Citizen Kane* (RKO, 1941), directed by Orson Welles, starring Welles (foreground), Joseph Cotton, and Everett Sloane (both at far end of table).

film stock What kind of film is in the camera. The crucial variables include the format of the film (16 mm, 35 mm, and 70 mm are standards), the sensitivity of the film to light, and the choice of black-and-white or color.

The Shot (Continued)

establishing shot Usually a long shot that shows the setting for the action to follow.

180-degree, shot-reverse shot A series of shots that shows two people in conversation from opposing camera angles.

point-of-view shot (POV) A shot supposedly from a character's point of view.

take, as in **long take** The filming of one action on one piece of film.

deep-focus A shot that puts both foreground and background in clear focus.

The Story

script The shot-by-shot description of dialogue, staging directions, and camera work, as planned in advance by the film-writer, director, and editor. They may use a **story board**—drawings of a complicated sequence in the order as they'll be edited later.

scene An action that takes place in a single location.

sequence A series of scenes which together compose a coherent part of the story.

segment The larger divisions of the film story, comparable to chapters in a novel or acts in a play.

set The physical setting where action is filmed. May be erected in a *studio* or sound stage especially equipped for film making, or may happen *on location,* in already existing building or landscape appropriate to the scene.

mise-en-scène (or staging) (French for "putting into action," pronounced "meez-an[h]-SENN)" The orchestration of all the physical objects—set, scenery, props, and actors—on the set (or stage) in front of the camera. Before the camera rolls, the production designer has created the whole "look" of the mise-en-scène by choosing colors, fabrics, props, and other physical elements.

Editing

post-production Laborious process of finishing a film after it's been shot. Includes editing, sound, special effects, and titles.

editing The process of cutting the film (physically or digitally) and reassembling the pieces to create a continuous sequence of shots and scenes.

cut As in "a cut" or "cut to …," meaning a break between two different shots in a sequence. "To cut" = to edit.

cross-cutting Alternating between different actions, usually in different places at the same time. A chase scene is usually cross-cut between pursued and pursuer.

fade-out and **fade-in** Image gradually disappears into or appears out of a blank screen. Often marks a story segment.

dissolve One on-screen image dissolves into another. Usually marks passage of time.

jump cut An abrupt cut between disconnected shots. An attention-getting editing device.

flashback A uniquely cinematic narrative device, in which a character

recalls an earlier scene in the action and the camera shows us the character's memory. Marked by a dissolve and music.

Sound and Effects

soundtrack Literally, the sound recorded on the edge of the film, read by the film projector, and broadcast in synchrony with the projected image. The soundtrack customarily has three parts or tracks: *dialogue*, including dialogue added in post-production; *music*; *sound effects*, including the texture of sounds (glasses tinkling, cars passing) that create the auditory ambience of a scene. Today, the term also refers to a recording of the musical section of the soundtrack.

voiceover A narrator's voice added to the soundtrack in post-production.

music Music composed during post-production to accompany the visual images. Film composers have to work quickly, using a final cut of the movie and precisely matching the music to action frame-by-frame.

rear projection A traditional special effect that projects moving exterior scenery behind an action shot in the studio—for example, the passing countryside behind a couple sitting in a car.

FIGURE 9.2 Scene from the movie *Double Indemnity* (Paramount, 1944), with Barbara Stanwyck and Fred MacMurray, directed by Billy Wilder.

computer-generated image (CGI) The general term for any element added digitally to the film image in post-production.

Film Miscellany

studio The place where movies are made and, by extension, the large companies that make movies.

independent ("indie" for short) A small movie making company not controlled by a studio.

expressionism A distinctive style developed in German cinema of the 1920s that used exaggerated sets and extreme lighting.

classic Hollywood cinema (also **American studio system**) The system and method of movie making established in Hollywood during the 1930s and 1940s.

neorealism A style that arose in post-World War II Italy, using actual locations and non-professional actors to tell stories of sober realism.

auteur (French for "author") Term applied to notable directors (John Ford, Howard Hawks) by 1950s French critics, who defended these directors as true artists with distinctive styles, not just studio hacks.

THE EXPERIENCE

WATCHING WHILE THINKING

Movies are such a compelling visual and aural experience that they tend to occupy all our attention. It's harder to think about movies during the experience than with any other art form. How to watch the movie and watch the movie-making.

Look at the shot. While the camera is resting on the action, look around at the shot: not just what the characters are doing and saying, but also at lighting, costume, set design.

What's the camera doing? Think of your eye as the camera. Where are you looking from? What are you looking at? What's in focus? Remember, your eye is being controlled by the director.

Follow the action and dialogue. With most good movies, you'll be drawn into the work by the characters and the action they're involved in. Nothing is more natural to the human mind than following a good

story. Let yourself be drawn in by good storytelling. Notice how the dialogue is written: Does it flow smoothly? Does it reveal character?

Parts of the story. Notice how the movie divides itself into parts—scenes, sequences, segments. In the composition of these parts, feel the rhythm and pace of the story's forward motion. When the movie's over, you can probably reconstruct the movie's largest segments as a context for your favorite or the most important scenes.

The acting. Now you can be the critic. How convincing and original are the actors in their roles? How has each actor interpreted the role? What scenes are especially compelling? How do the actors work together on screen? How does this performance by an actor compare to performances in other films?

The directing. These days, the director is the one most likely to be credited for the movie's success. Assess the director's decisions in casting the principal roles, in governing the pace of the action, in keeping the story coherent, and in imprinting the story with a distinctive style. Compare this movie to others by the same director.

Consider the screen writing, photography, music, editing, or design. The better you get at movie watching, the more you'll notice these creative aspects of a movie. You'll enjoy movies more. And you'll be able to say why the movies you like are good movies and the movies you don't, aren't.

The context. Perhaps more than any other medium, movies today reflect historical and political issues. Judge the movie as a commentary on the cultural and political state of affairs at the time it was created. Notice the genre that it can be assigned to and the other films that it compares with. If the movie is a social commentary, how would you respond?

STYLE GUIDE

MOVIE GENRES

Western From John Wayne to Clint Eastwood to Brad Pitt—every generation of actor and audience seems determined to keep the cowboy alive.

crime Cops and criminals seem to bring out the best in American movie making; Francis Ford Coppola's *Godfather* trilogy in the 1970's was

the culmination of a movie genre that began with Howard Hawks' *Scarface.*

comedy In its classic Hollywood version, known in two varieties—romantic and screwball. These genres continue to provide movie vehicles for such contemporary stars as Julia Roberts and Eddie Murphy.

musical Like the stage musical, the musical film was based on a story line that called for scenes with singing and dancing.

costume drama (also **historical drama** or **heritage** film) Set in a historical period that allows for showy costumes and grand sets. The greatest of all were *Gone With the Wind* and *Ben-Hur.* These days most likely to be based on a novel by Henry James or E. M. Forrester.

film noir As much a style as a genre, 1940s-era film noir (pron. nwah(r), "black") used shadowy lighting and hard-boiled dialogue to tell stories of betrayal, corruption, and suspense.

suspense thriller or **mystery** Alfred Hitchcock defined this genre with movies such as *North By Northwest* and *Psycho.* Every director of a thriller since then has worked, happily or not, in Hitchcock's round shadow.

action/adventure A reliable box-office standard, starring everyone from Errol Flynn to Mel Gibson.

science fiction Perfected in our times by Steven Spielberg and George Lucas—*Juraissac Park, Star Wars*—science fiction employs the latest in special effects and reflects every decade's fantasies and anxieties.

war movie The ultimate male experience celebrated in movies, from Robert Altman's madcap *M.A.S.H.* to Spielberg's innovative *Saving Private Ryan.*

coming of age Though often trivial, these stories appeal to the teenage audiences that buy the most movie tickets.

documentary Though not often seen in your suburban multiplex theater, documentary continues to attract some of movie making's most committed young talents.

animation An entire branch of movie making in its own right that requires frame-by-frame shots of cartoon drawings. Long the domain of Disney Studios, the 1990s saw feature-length animations by several other big companies.

A Companion to the Movies

Title _____

Director _____

Actors _____

The shot

long/medium/close-up _____

lighting _____

camera angle _____

camera movement _____

The scene

acting _____

music _____

direction _____

The story

characters _____

plot_____

dialogue _____

principal segments_____

The acting

leading and supporting roles _____

casting_____

The director *Individual style, other major works, biographical context*

The type or genre

❑ Western ❑ suspense/thriller ❑ musical ❑ comedy ❑ war movie

❑ science fiction ❑ action/adventure ❑ coming-of-age ❑ crime

Photography, editing, music, special effects

The context

historical _____

social _____

political _____

Your response *What you like, what you think, what you feel*

10

ENCOUNTERING THE ARTS

I admit it: I'm a culture addict. Anytime, anywhere I plan to travel, I pull out my clipping files and scan the Internet to see what's playing in town and what's showing in galleries or museums. Once I've arrived, I try to reserve a day just for cultural exploration. I once spent a wonderful day in Chicago's Loop on a meandering, self-guided architecture tour. It was my first time with art deco and I fell in love with those buildings.

It's not that I wish my addiction on anyone else. I do wish that every weekend—and every day you spend in a great city—you'd seek out a rewarding encounter with high culture.

TOURING A CITY

Yes, high culture congregates in cities. If you're fortunate enough to live in a great city, every day offers you a cultural smorgasbord. Likewise, if you live on a college or university campus, you probably have more cultural choices than you have time for. But if you live in the provinces, away from urban concentrations of high culture, a chance to spend a day or two in San Francisco or New York demands a plan.

Before you travel. I start with research, using guidebooks from my own bookshelf or the public library. These days there's also a wealth of Internet sites that guide you to cultural attractions and current performance and exhibition schedules. I usually find there's no substitute for an up-to-date guidebook for information on cultural attractions, transportation, and dining and hotel choices. In the margins, I keep notes for reference on future visits.

Making a plan. I start by choosing my must-sees, the things I don't want to leave town without doing. It may be a performance of the San Francisco Symphony or a Yankees baseball game. Once I'm committed to these, I fill in the rest of my daily itinerary. Usually, my top priorities leave time for some second choices, or put me in the neighborhood of other opportunities. Maybe it's a little museum near the concert hall (see the list of don't-miss little museums), or a free afternoon before the night game. The preferences of my traveling companions affect my choices, of course. I'm always on the lookout for affordable restaurants strategically located on the day's tour route.

Getting there. Your itinerary needs to consider the time it takes to get there. I like to walk in big cities, but public transportation will usually get you there faster and fresher. The cost of a taxi has to be weighed against the value of the time you spend walking or taking the bus. Here, the locals can help you decide. Ask them.

On the way. A great building may not be your final destination, but I try never to miss the chance to detour past and through a choice building on my route. Leave time to stroll into the lobby, ride the elevator, and touch the handrails of an architectural masterpiece. You may never walk down that street again.

If you're with a tour group ... you won't have as many choices to make, but you can still please yourself. Keep an eye out for places and objects that aren't on the tour, but on your list of wanna-sees. Depending on your tour guide's tolerance, it's usually okay to linger a moment or wander off the assigned path without losing sight of the group.

Dress for versatility. When I leave my hotel room to tour a great city, I try to dress so I can comfortably walk in a park, tour a museum, eat in a pretty good restaurant, and attend an opera performance, all without changing my wardrobe. For me this usually means comfortable walking shoes (not athletic shoes, which are wrong for the restaurant and the opera), a jacket with pockets, an umbrella, and a compact shoulder bag. Whatever it means for you, is what you need to pack in your suitcase.

The value of reflection. I'm a journal-keeper, something of a dying art among educated people. If you're a storyteller and you tell the story of your experience enough times, that may be all the reflection you need to savor the experience. But I like to write about it, and in my journal I keep the postcards, clippings, and other miscellany that help me recol-

lect my experience. Next to the travel books on my bookshelf, there's a little row of journals that record my best days in great cities. There are memories of strolling past Frank Lloyd Wright houses in Oak Park, Illinois, on a brilliant fall afternoon; stumbling onto the Hôtel de Soubise, a rococo architectural gem in Paris; and simultaneously savoring Chardin paintings and a plate of paté during a decadent solo lunch in the Metropolitan Museum.

VISITING A MUSEUM

Make a plan. If you're a student of the arts, study what's in a museum before you go. It's a thrill to discover a work of art in the flesh that you've known only as a book illustration or classroom slide.

Get a map. Museums are funny. They organize their collections in lots of different ways. The Gallery of the Uffizi in Florence follows a strict chronology. The National Gallery in Washington, D.C., is arranged by national style. The Louvre in Paris ... well, let's just say, the world's greatest museum doesn't have to explain itself and it's a good thing. So get a map and plot a route.

Find what you want to see. Use every means available to discover what you came for. Museum guidebooks are great, but they're heavy. Bet-

Great Little Museums

The Phillips Collection, Washington, D.C. An exquisite collection, strong in impressionism and early modernism. Renoir's joyous *Luncheon Party* is here.

Musée Marmottan, Paris. A basement full of Claude Monet's great *Water Lily* murals and the Monet painting that gave impressionism its name.

Frick Collection, New York. Located in the Fifth Avenue mansion of Gilded Age tycoon Henry Frick. Old masters, including Vermeer, Rembrandt, and Goya.

Borghese Gallery, Rome. Full of sculptures by Bernini and paintings by Italian masters, the Borghese is located in a luxurious palazzo just outside Rome. A decadent Roman cardinal built the estate in the 1600s to showcase his stupendous art collection.

ter to follow the suggestion of Thomas Hoving, former director of the Metropolitan Museum. Pause at the museum shop or kiosk and scan the museum's postcard selection. Buy postcards of the works you're most interested in. Hold the postcard up to a museum guard, look quizzical, and you're sure to get directions to your destination.

Pace yourself. Too many times I've seen tourists with glazed eyes, traipsing through the National Gallery or the Louvre as if on a forced march through high culture. Stop. Assume you can only really enjoy a couple of dozen works in a half-day's visit. Be selective, concentrate on what you came to see, and blithely stroll past everything else.

Savor serendipity. For me, every visit to a museum promises some surprise. Whatever my plan, I try always to stumble on to something I've never really looked at before.

Audio tour guides. These inspire in me mixed feelings. The texts are usually authoritative and impeccably written, but they tend to lead you by the hand, making choices for you and substituting their judgment for your own. There's nothing more disheartening than a special exhibition filled with people following their tape guide like sheep, not talking to each other or thinking much for themselves. If you use audioguides, turn off the tape regularly and look for yourself.

Museum Manners

Don't touch. The dirt and oil from your fingers, added to thousands of others, will soil and damage the art.

Don't beep. Turn off your beeper and cell phone while in the galleries. This isn't the time or the place.

Do check your backpack or large shoulder bag. You can easily bump into an artwork and damage it.

Do strike up quiet conversations with anyone who looks interested in the same thing you do. This is art, not a collection of sacred relics.

Do get up close to see just how that artist did that brushstroke or hatching. Then step back to give other patrons a clear view.

Do support the museum with your donations and museum shop purchases.

Look, think, talk, and write. If you're touring the museum with a companion, share your observations and reactions. Often, two pairs of eyes are better than one. If you're by yourself, pause to record your observations and reflections in a journal.

ATTENDING A PERFORMANCE

Get a ticket. The box office can probably tell you if tickets are easily available at the door, or if you'll need to purchase in advance. If you're a student or an elder, ask about discounts.

Read up. I believe the more you know, the more you can enjoy. So read anything you have at hand that might enhance your pleasure in the performance. The newspaper previews, the Internet, the library, even this book—anything is something, and several things can be quite a lot.

Dress comfortably. This is the twenty first century. Nobody's worried about impressing other people with their wardrobe ... well, hardly anybody. At the opera's opening night, there will be some black ties and some blue jeans. On a chilly winter evening at the theater, you'll see more sweatshirts than mink coats. I'm comfortable just a little dressed-up—a jacket, and for the opera, a tie—but you suit yourself. Believe me, you buy a ticket and the producers and performers won't care what you wear.

Arrive on time. Many music organizations offer lectures or other pre-concert events. Take advantage of them and you're guaranteed a good parking space. I always take advantage of uncrowded restrooms before I go to my seat. The lines will be longer at intermission.

Scan the program. On a music program, notice the principal works and performers. At the opera, read the plot summary. At the theater, note the cast. I like to review the program after the performance, too.

At intermission. Refresh yourself with drinks and snacks for the benefit of the sponsors. Nearly every cultural organization in the United States is under-funded. Your soft drink and candy bars put a few more pennies in the coffer and help assure there'll be a next performance.

Watch, listen, think, talk, and write. Share your reactions to the performance with anyone who'll listen—your companions, the stranger

next to you at the bar, or the parking lot attendant. Write to a friend about your experience. Record your reflections in your journal (this is when I like to review the program as a memory aid). Our experience is richer when it's registered in writing and conversation.

Performance P's and Q's

Don't beep. Turn off your beeper and cell phone before you walk into the auditorium building. If you have to call at intermission, walk outside. Other patrons will thank you.

Don't sing or hum along, no matter how much you love the music.

Do applaud at the appropriate times. During a symphony, that's only at the end, not between movements. During a play, it may be at the end of a scene or act. When in doubt, watch someone who looks like they know what they're doing. Do what they do.

Do arrive on time and take your seat a few minutes before curtain time.

INDEX

NOTES

NOTES

NOTES

NOTES

NOTES